DIVIDED

Published in the United Kingdom in 2021

Divided Publishing Ltd
Avenue Louise 251, level 2
1050 Brussels
Belgium

http://divided.online

This book was made with support from de Appel, Amsterdam, The Breeder, Athens, and Central Fine, Miami Beach.

Front cover design by Michael Salu
Printed by TJ Books, UK

2nd edition, 2022

ISBN 978-1-9164250-7-1

Georgia Sagri

STAGE OF RECOVERY

Acknowledgements

A voice runs along the text like the edge of the river's wet grass and the yellow marks on a pillow. The mark is yellow because everything is the mark. Yellow mark, fluorescent, my saliva is bitter, there is suffocation and a bloated stomach, rapid heartbeat, cold sweat, weak breathing, and my entire skin is red and in pain. It is time I thought, the poison is coming out. I turn, my knees tremble, I start vomiting yellow. My body is in an extreme state and I really don't know why. Is drinking water helpful, why don't I have any knowledge of what I am experiencing? The question is a common one, when we force ourselves to understand a situation and realise we are part of it. In the year I spent lying in hospital not able to move, I realised that I am the one who needs to open up a conversation about what I am and what I need to feel better. When the doctors prescribed cortisone to mute the crisis I got a swollen head, became hairy and weak, and I knew that what I had wasn't gone. I was twenty years old and my body was in a complete sleep. The first friend I acknowledge is Christos who put me in contact with a homeopathic doctor. What we are is not what we have in our minds that we want to be, that is what others tell us to be. What we are is that which is revealed. I felt the cortisone, the painkillers and other addictions preventing me from knowing through observation, separating me from a knowledge which is clearly not something easy. I needed to confront what I am, surrender to pain fully without fear. When I arrived at the island I stayed for two and a half months, it was September 2001, I had just vomited out most of the poison and the pain was surrounding me slowly and steadily. I realised there is something peculiar about the entire system, a system based on power that comes from destroying someone else who is supposed to have power. It goes on like that endlessly, and certainly I am not interested. I walked back to my spot by the mountain and I made a promise to observe, to know and to practise not for power's sake. If everything is moving according to the principle of power, how am I going to live

within it without surrendering to it? I will be devoted not to finding an answer but to practising the question. Making art means that you are always equally whole and nothing. With art you always end at nothing and start with nothing, that's what practising art is. Thinking in motion. History in motion. Another person arrives at this time, my cello teacher, who told me that you always need to play no matter the result. More friends, childhood friends, Sam, Eva, Irene, and others, Kostas, Yiorgos, Antonakis, Dionisis, Eleni, Augustine, Xenia, and another teacher, Rena, came along when I was starting to recover and realise that what I want to do is performance. Rena told me that the path is difficult, and I said that means I am on a good path.

Nikos, Vasilis, Loraini, Yiannis, and when my body started to feel stronger I ran away from the order of my everyday life which was centred on my health. The doctor was certain that I needed to continue with a careful diet but I went in the opposite direction. I started drinking and smoking, doing all kinds of drugs, to be sure I knew different states, and how my body reacts to different kinds of plants, mushrooms, poisons. Until the heavier drugs it was a ride, there is a friend I acknowledge today because he almost turned me into an addict again, and he was one of the reasons I left Greece.

Alexander

How are you?

I made my entrance

into the world

with a golden glove

I was scared to death

for every woman's

bone

who was born

after me

I gave everything at the allotted hour

at the morning's silence heavy thunder

I was never gone

I'm still here

between two worlds

no heaven

no hell

between the horizons

of sea

and sky

skin

sell

silk

Alexis

On Saturday 6 December 2008, Alexandros Grigoropoulos, a fifteen-year-old comrade, was murdered in cold blood with a bullet in the chest by a cop in the area of Exarcheia. Contrary to the statements of the politicians and journalists who are accomplices to the murder, this was not an 'isolated incident', but an explosion of the state repression which systematically and in an organised manner targets those who resist, those who revolt, the anarchists and anti-authoritarians. This is the peak of state terrorism which is expressed by the upgrading of the role of repressive mechanisms, continuous armament, increasing levels of violence, the doctrine of 'zero tolerance', and the slandering media propaganda that criminalises those who fight against authority. These conditions prepare the ground for the intensification of repression, attempting to extract social consent beforehand and arming the uniformed state murderers with weapons. Lethal violence against the people in the social and class struggle aims for everybody's submission, serving as exemplary punishment, meant to spread fear. It is part of the wider attack of the state and the bosses against the entire society, in order to impose more rigid conditions of exploitation and oppression, to consolidate control and repression. From schools and universities to the dungeons of wage slavery with the hundreds of workers killed in so-called 'industrial accidents' and the poverty embracing large numbers of the population ... From the minefields at the borders, the pogroms and the murders of immigrants and refugees, to the numerous 'suicides' in prisons and police stations ... From the 'accidental shootings' in police blockades to the violent repression of local resistances, democracy is showing its teeth! From the first moment after the murder of Alexandros, spontaneous demonstrations and riots burst out in the middle of Athens. The Polytechnic and the schools of Economics and Law are occupied, and attacks against state and capitalist targets take place in many different neighbourhoods and in the city centre. Demonstrations, attacks and clashes erupt in Thessaloniki, Patras and Volos,

in Chania and Heraklion in Crete, in Yannena and Komotini, and in many other cities. In Athens, in Patission Street – outside the Polytechnic and the School of Economics – clashes take place all night. Outside the Polytechnic the riot police make use of plastic bullets. On Sunday 7 December, thousands of people demonstrate, moving towards the police headquarters in Athens, attacking the riot police. Clashes of unprecedented tension spread in the streets of the city centre, lasting late into the night. Many demonstrators are injured and a number of them are arrested. We continue the occupation of the Polytechnic which began on Saturday night, creating a space where all people who are fighting can gather, and one more permanent focus of resistance in the city. We keep alive the memory of Alexandros in the barricades, the university occupations, the demonstrations and the assemblies. We keep alive also the memory of Michalis Kaltezas and of all the comrades who were murdered by the state, strengthening the struggle for a world without masters and slaves, without police, armies, prisons and borders. The bullets of the uniformed murderers, the arrests and beatings of the demonstrators, the chemical warfare used by the police forces, cannot impose fear and silence; instead they become the reasons for the people to rise against state terrorism, to struggle for freedom, to abandon fear and to meet – more and more every day – in the streets of revolt. Let rage overflow and drown them!

One afternoon in December 2008 something changed in the way we talk, the way we think, in what the youth hope the future is going to be. In the evening we met on the streets to cry together over the death of a boy.

This summer had too many eclipses

This summer had too many eclipses, retrograde planets that pushed us to detoxify from breakdowns, betrayals, pain, catastrophes and fears, and also found us closer to each other, together, trying to make sense of it all. Some of us decided to go to forgotten islands in faraway parts, making wishes and inventing rituals to forgive this dark matter that is haunting us. Then fires burnt forests, animals, houses, people, families and children. And we cried together for all those spirits. We talked to understand, to get it off our chests, to verbalise our anger and to find a way to move. To do nothing by decision could be something to fight for. To do something out of need is when life is not about give and take, but just is. We need to reflect, we need to try to stay true to our feelings and to allow ourselves to be completely sad for what is going on, to fight and find each other in disagreement, to speak out and to allow ourselves to listen to each other. After a while Sarah found some time to read and write at her own pace, and established some strength to start her dissertation. Destiny dreamed of a performance she might be able to do, and walked in the sand for hours. We swam. She took photos of the plants. We gathered wild oregano. We read our wishes to the waves. In and out of the company, more friends were adding to the mood: Calamity, Nora and Mayra. We merged completely with each other, spending time together. When I needed solitude, I stepped onto a rock and turned my back, looking away from where everyone else looked, and then I was away in silence.

One of the main topics of our conversation was the maintenance of Ὕλη[matter]HYLE, the space in Athens. How to stay anchored to the position of Ὕλη[matter]HYLE, and not to become involved in any of the postures by turning it into either a non-profit or a profit-making space, but to operate from the needs and care of those who cultivate an ongoing relationship with the space itself, and with each other. The biggest challenge, and the one that compels us to continue, will be resisting a legal framework for the space, which

would immediately place all the participants under the vocabulary of capitalism and state civil contracts. Our artistic and everyday participation – don't call it politics – would be transformation from within, the wish for a revolutionary animism to spark from within. The space, the place, the home, the house and its walls, the doors, the rooms, the corners and the shifting of the light, the passers-by (all of them) walking sometimes to similar destinations, other times in different directions. Capitalism and much of western European history conditions us to perceive the world through opposition – this is outside, this is inside – this is dominant, this is subordinate – this is material, this is immaterial: it takes a lot of work to change this. We are always defined by dichotomy in this society and in terms of profit rather than needs, there must always be a group who oppresses another that takes the role of the inferior. There have been many attempts to theorise, criticise and make meticulous observations of where the enemy is, how it acts, what form it takes. I decided to watch from the balcony, another token of a place that is not really inside and not exactly outside. This is what I need for now, to observe the rhythms, listen to the tempos, look at the moves. How can you demand peace for you and your friends when there are so many wars going on around you? I will finance it with my teaching job, and it will figure itself out as it progresses. It feels right this way. I don't want to own the space, I want to be part of it, and it will grow through those who simply like to be here. The space is called Ὕλη[matter]HYLE. A strange word – it might mean 'wood', but I always thought it is like a curse of a word, because it is nothing until it is named as something.

Hasn't the house been the matter that women were never allowed to give their own form to? The house is the square, the grid, the order and the corners. Some ask politely how I feel, and some don't really care. The house is an assemblage of elements, voices and tempers. Modular without an end and a beginning, without asking for something there is

no taking anything and without taking there is continuity: of the conversation, of the pleasures and the movements of people, sentiments and experiences. Here we go again. The assembly is the gathering of bodies, emotions and states of mind at the time of their making, which is the 'keep on going' of the conversation. That's how I understand the social, the continuation of the conversation. Totalitarian capitalism, institutional bureaucracy camouflaged by neoliberal dream-worlds gives ready-made solutions. Patriarchy is the creation of desires never to be satisfied and the end of the voicing of needs. We read the critiques and the hopes of the Occupy movement, and we read how the assembly was analysed by white heterosexual men as an enclosed form with particular attributes. But some of us have the memory of what was the intelligence of Occupy: its unpredictability, formlessness and its osmosis of variables. Now we experience the city and the house taking shape from Airbnb and the real estate monop-olisation of the economy of livelihood. State capitalism and corporate neo-feudalism keeps us busy with the construction of more enclosures. Is this life that we are living?

Mayra returned to Athens and met with Nora, Nora decided suddenly to experiment with heterosexuality. I am trying to understand what is the purpose of the space, if it is not a house, and if it is not an artist-run space, what is it? Does it really need to have logo? Does it need to have a purpose? All of this in the middle of a cold winter when Mayra is perform-ing at poetry readings and I am still not able to walk along Gladstonos Street where Zak was murdered. Mayra didn't know Zak. It is devastating to try and continue a conversation when I am motionless with anger. None of my friends want to actually discuss this horrible murder, they only talk about justice. Mayra is reading to a handful of people. She seems so very black in the white room and she is completely aware of it, reading out loud, smiling. After her reading I hugged her so strongly, we went for dinner and it was the first time I was able to walk along that street. I told Mayra about Zak's

murder and we left a rose beside a candle that is still lit out-
side the shop where they were killed. We were together when
Sarah wrote that she is going to be in Athens in May. After a
few months I arrived in New York to give a lecture. I wanted
to present the limitation of the idea of origin. I started mak-
ing drops of colour on white paper.

Orange drops on the white paper. Then some pur-
ple drops. The distance between them makes them distinct
from each other, but also complementary. When there is
only orange there is nothing else but orange, and when
there is purple after orange there is much more than only
orange, there is purple too, which means that it is not only
about orange but the relation of orange and purple. If we
were to say 'orange came first' then certainly purple 'arrived
later', and then all the characteristics of purple are in rela-
tion to orange. A bit late as it is, purple would always be in
accordance to orange. The first is orange and then purple,
after orange. The time needed for purple to become dis-
tinct from orange will be quite long. The expenditure of
energy will be enormous, because purple by being already
late will always be defined like that, late and always in rela-
tion to orange, which was first. It would be difficult for pur-
ple to imagine a world without orange or without being in
relation to it. There will always be the impression that pur-
ple arrived after, which means that anything that happens to
purple without orange would be all about the whole drama
of separation from orange, and not at all about what purple
accomplished in trying to get some time for itself. So, here
are the orange drops. They seem lucky just sitting there on
the paper. Here we see the orange drops with purple. What
do we see? Orange with purple, not purple with orange. That
would have happened also if the story were reversed: if pur-
ple were first then orange would be late. And all that we said
about orange would be the characteristics of purple. No mat-
ter what the essential characteristics of orange or purple are,
we would always think that this one was first, and then the

other came, and so on. What if I give one minute to orange and one minute to purple and then one minute when they are together? Equal time perhaps is a good strategy for equal space without origin.

Anarchy means 'without beginning', time is the core of its definition but not order. The shift points to how we endorse difference, cultivate desires and situate the boundlessness of pleasures, opening territories towards everything. The political contextualisation of how we understand anarchism is always as an ideology, but anarchism because of its timelessness is a practice. It is a momentum, it is an ongoing formation and gathering, collectivised forces, social organisation without beginning, without normative identities. We cannot talk about organisation if we are in an enclosed perception of time. What are our paradigms for the organisation of time? Who is the author of your time? Could clandestine communes, migrant caravans and the nomadic settlements of indigenous people be our time-paradigms? Our time-paradigm is the emergency of the erotic redistribution without the enclosure of the couple and the nuclear family, which was in various ways the utopians' philosophical demand. Today's need is to break the screen of sexuality and its representation and to get to know the reality of our bodies, no longer as a demand and origin, but as an ongoing practice and a constant sexual revolution. This is our time-paradigm. This is revolutionary animism without beginning.

This is about life practice, the economies, the ecologies of an *oikos* (home) in a typical Athenian apartment in a *polikatikia* (apartment block), a building located on a *stoa* (shopping arcade) surrounded by the urban chaos of Omonoia Square in the centre of Athens. It is small apartment with an entry hall, two living rooms and a corridor leading to one bedroom. Ὕλη[matter]HYLE aims to call for social activity of all kinds, but, often, this work is not seen as work. That is a problem, because the space could offer political and artistic programmes, but first there is a need of communities that are

able to reproduce their lives, and I don't see those communities existing right now. People seem to be too fragmented in different social bubbles to deal with loneliness as a group activity. I insist on not choosing between the individual and the collective. I feel that within the spaces we build, we need to recognise the existence of both the collective within the individual and the individual within the collective. What I have noticed is that there are still obstacles to overcome with regard to the dichotomy and expectations built up around the ideas we have about public and private modes of production, the ideas that an art space and the home may provide.

The current paradigmatic example involves who is doing the art and who is doing the work. Who is productive and who is reproductive. Who is doing the public intervention and who is in the safety of the domestic. I am often confronted by those who think that simply being in the space and doing nothing, relaxing, cleaning the dishes, is not part of the art but part of the home. To do art, for some, is about exhibiting one's work, organising events, discussing matters. To do activism, for some, is to force a particular subject and goal with an aim and a political effort. Cleaning dishes is either part of the work or part of the leisure. Cleaning dishes is part of the domesticity that could mean privilege or suffocation. Reproduction is not separated from production via the sexual division of labour, you cannot critique labour through the prism of this dichotomy. The two are interconnected, therefore value is only produced by their constant co-dependence and friction. Global financial capitalism, as abstract as it is, needs bodies to circulate its programmes. Subjects identified as men and as women are living as slaves under the same conditions – as accessories to the market, and the property relations that implies. There is no production, only reproduction of the market, which is taken as a total truth.

Corporate industries, social media platforms, foundations, profit-making and non-profit institutions, technological laboratories for the humanities, innovations, act as 'feuds';

each one with their different relations to their production, but owners both of the land and of the house, the private and the public, the social and the personal. The inequality between the conditions of the industries and the people, the diminishing of labour at the level of non-waged work creates non-division between production and reproduction. Every exchange takes place between people with capital, mediated by different corporations. This is a highly complex relationship because life involves industries that involve people who identify with a particular entity (corporation, foundation, institution). Now everyone works all the time without really having a job, obliged to sell labour-power in its capacity for the production and reproduction of a total power. All labour falls under the category of care labour with regards to this total power of the market. Adaptable in such a way that it becomes both a personal and a social issue, and it is all indirectly wage labour. The degree of complexity of this exchange between beings and corporate industries is not only the form, but also the act and means of the exchange, as well as its essential condition. This is very different on a formal level from the exchange between capital and an ordinary worker of the old type.

To take care of the space is to resist choosing those who know more than others – between those who are already included and those who want to belong – to build respect for the space, not because it is yours but because it is everyone's. And this could create the momentum that would enable skills and interests to emerge, and pleasure and joy to appear. Many institutions are obviously completely fixated with dichotomies: project versus process, public versus private, exhibition versus event, production versus management. Residency programmes, art centres, project spaces, artist-run spaces, art associations, kunsthalles, museums – these are all places that insist on maintaining the dichotomies between the object and subject, between immaterial and material production, between paid and artistic work, between work and art, between the private and the public.

Perhaps, through breathing techniques, the binaries, the existing perceptions and the violence of having to choose may go away.

From the autonomous occupation of 90 Fifth Avenue, New School occupation

Since 17 November, students, non-students, workers and others, through political occupation, have transformed a formerly isolating, frigid and closed study space into a twenty-four-hour educational hub not just for all students, but for all people. We have held this space for seven days, and in that time we have set up multiple General Assemblies, established a safer-spaces group, created gender-neutral bathrooms, fed and housed over two hundred people, provided teach-ins from an anti-capitalist and anti-racist perspective on the financial crisis and political struggle, and created a gathering place for political conversation. In reclaiming a building of the New School, a private university with astronomical tuition fees, there has, at times, been the perception of elitism and exclusivity; some have said that they feel alienated, that the space is still too white, or that the theoretical discussion is pretentious or too academic. Some of these issues were not resolved, nor could they have been resolved in such a short window. This contradiction – where anti-capitalist and anti-racist debate is viewed as an elite politics – is precisely what we are in the process of shattering in this space. Hundreds of people have come to hear talks and have conversations about capitalism, revolutionary practice, anti-oppression, queer politics and international struggle. Most who have had problems in the space have consistently returned, recognising that the politics surrounding the occupation are not solidified, but are instead immanent to the space itself.

Last night, 22 November, marked the first attendance of many emphatic participants at the General Assembly. Through bureaucratic manipulation, including a broadly attended town hall created at two hours' notice, the assembly was packed by antagonists including several faculty members and a large group of students who had not previously been involved in the occupation. For many of us the large attendance seemed like a success, but very soon it became clear that the sole goal of the majority of participants present was not

discussion, but a yes vote for the destruction of the occupation. The intention was to disrupt any possibility of dialogue and to frame the voting of the assembly in the manner of representational politics and parliamentary theatre.

At this assembly, the faculty, the bureaucratic manipulators, and students hand-picked by the administration revealed their faces. Arguments about race and alienation, pro-capitalist rhetoric and theatrical fear-mongering were used to disrespect and disempower the open assembly. Immediately after a perceived victory in 'accepting' David Van Zandt's proposal, after voting these individuals removed themselves from the process, and demonised the continuing deliberation of the assembly's remaining participants.

We are writing to expose the misinformation and the constant sabotage that is circulating through the media, disseminated by specific individuals whose only purpose is to break this occupation from within. We also see this document as an opportunity to put forward a political perspective on these events, and our hopes for the future.

It is clear that we should not have trusted negotiations with the president of the New School about the security and character of this occupation. After six days of dealing with this matter it is evident that it has caused fragmentation, not only of the occupation itself: it also poses a larger threat to the entire student struggle and the growth of the occupation movement. Political organisations, still playing ping-pong on the back of the student body, in favour of specific ideological positions and with vested interests, have succeeded in the creation of media misrepresentation, the recruitment of students against the occupation, and the disruption of any possibility of dialogue. This has been done only for their own benefit, to legitimate their bureaucratic actions, and to expand their conservative, archaic way of organising. They refuse and are unable to transform this method of organising when confronted with a movement that is against any form of leadership or representation.

The struggle can only develop with the opening of a space that is initiated by a political praxis that remains open to all kinds of political analysis.

Any jeopardisation of autonomous practice will doom the struggle to failure.

23.11.2011

Occupy 38

How can the rest of New York City remain unoccupied?

The answer is that it cannot. The rest of New York must be occupied.

The third floor of 38 Greene Street is now occupied. It is a place where police, bureaucrats and the media are not welcome.

The space is open. Come. Join the conversation. Join Occupy 38.

General Assembly at noon.

http://artistsspaceoccupation.tumblr.com

23.10.2011

On the wall

After seeing the 2011 NYC Occupy movement that I was part of demonised, accused and witch-hunted by the New York art and political scene for not being properly politically aligned; after initiating the Artists Space occupation and being called all kinds of names, including that of anarchist, in the New York media (being in New York on an artist's visa); after seeing my friends and comrades settling into the misery of the day after the symbolic comfort of what they wanted so much to make out of Occupy; after all this, I returned to Athens to renew my passport and got blocked there for a year, with my passport held for 'unknown and unsaid reasons' at the United States Embassy. I was in a surreal state at the end of 2012 in the city where I was born, after almost ten years of semi-absence. In the midst of this unstable state I was invited to participate in the Lyon Biennale. This was the text I wrote during my participation. It was a very unpleasant moment; reading this again I now understand very clearly why I was feeling so frustrated.

I am not here just to attack. I do want to say that my experience with art organisations and some mega-curators hasn't been pleasant. I've been asked to be something that I am not. I've been asked to do things only in order to preserve a role of what the institution thinks the artist is, and of what performance art is.

Some institutions never ask what you need or make clear what they invited you for, you just need to perform what they want you to be. When I said what I wanted it wasn't approved, still I have to find a way to present my work in the Biennale. Isn't that a contradiction? Isn't that a waste of time?

For me what is happening in this city, in the nearby areas of this neighbourhood is interesting to explore, to question and to work upon. I haven't been supported in doing what I really want to do, and I don't feel comfortable because it is always asked of me to perform a role that I am not, and no proposal is accepted for what I really need and want to

do. The only thing institutions do is take ideas, thoughts, and preserve their power. Staff and curators get their salaries, get their bonuses and keep on having jobs. In this modality I can't consider the people who work in institutions as allies. It seems they are just curious to know what they will never try to reach themselves. They frame the things they are not part of, and they have no desire to be part of them at all. You, on the other hand, you who have this leaflet in your hands, you could ask your neighbour, ask and learn from each other what the problems of your area are and how you can create solutions together. I mean that this can be a small step towards understanding that nothing can be created on its own or by anyone else other than you. The sea waves in California are made of the humidity in Africa, the explosions in the centre of the earth can kill hundreds of people. The way we interact creates strength for words to be spoken, learned, and to become action.

What I find very disturbing in terms of the possibility of doing things or meeting people or activating questions is that, from what I have witnessed in the past twenty years, the world's cities are invested in and exist through the cultural stimulus and production of institutions and biennials, which themselves have been abandoned, literally abandoned by the intellectuals, artists and people who are actually producing thinking in our time. The institutions and biennials have been put into the hands of the corporate manufacturers of cars, beverages, cigarettes, weapons of mass distraction, drugs and products of all kinds; they have been given over to the state's private interests that have nothing to do with cultural ambitions, or with the creation of challenging exhibitions for the benefit of the world, instead they have the sole ambition of making money. The same happens with the universities, the public spaces and every inch of where we could live our lives. Everything is abandoned for the making of money and the stability of the few who exist through money-making, and who only exist in this way.

Even critique, questions and reactions feed private interests because they give them reasoning. Then we think we just need to make our small isolated group, in some faraway corner of the city that no one knows about, and live this way. By doing so we abandon the maps, spaces and locations to corporate real estate interests. This is not an intentional move on our part as a society, as people; there is cynicism, there is nihilism, there is oppression and surveillance; there are many mechanisms of control that prevent us from doing what we want.

There is no reason to talk about art and to extend the continuation of any art institution, any biennial, if we don't acknowledge that nothing is left to us to live and make art within. We don't have a left politics, but we have an increase of the extreme right, we constantly reject imagining something different for our lives and for the future. What scares me most is the lack of discussion about what is going on. We are afraid to actually talk about what is really happening in the present. No one talks about the present. There is one, and I feel it now with you. It is my only weapon. The present is that a group of friends are in a circle, here, and we are capable of doing anything we want, now. There is no convenience of belonging, only the presence of our bodies here and now, and our decision to do is the only thing that we have. We can do anything we want if we decide to do it now. There is nothing other than this moment of our decision, and only that. I am not alone now that I am part of this circle of friends, which decides to do, not a heroic gesture, but just doing for the pleasure of doing together. There is no minute left for discussion, planning or explanation. It is clear that the urgency of us doing is more important than the articulation of definitions or naming. We need to be aware of our presence to actually do something. The thing is to act outside of the satisfaction of myself. Can you see the bullshit? Everything around us is a plasma screen, nothing exists, it is all dead, everything is death. This architecture is fascism, the fascism of capital's

increase that does not include anything other than death. In order to continue operating it accumulates dead ideas, tastes, emotions, acts and sells them back to us as new, and we need to buy them in order to survive as dead bodies. It is a necropolis, and the only thing that can perhaps be life is what is happening here in this circle of friends talking about being dead; we realise now through having this discussion that we live a little bit, we feel something and then we do, and we live. I am not talking to pretend I am talking. I am not talking because I need to convince you that I need to exist as a subject. There is a desire forming out of what we are doing now and the pleasure we share now, here, in this circle of friends and in the dynamic possibility of expanding this circle. We don't have anything. I am dead with a few moments of life, so we need to stick together. The issue is that no one that works for the art institutions wants to understand that they are also dead, that we are in the same situation. I can describe society from my perspective and conditions and stay in that; on the other hand you can recognise that someone else's conditions transform yours. The way corporations operate depends on a chain of complicated decisions. That form is articulated from the bottom-level worker to the director of a company. There is a need for satisfaction, happiness and acceptance so that nothing else can happen except the maintenance of this form. But we are all disappointed by what we produce and what we are doing, working in a big institution that we have no voice in, only a voice that doesn't threaten capital. We are excluded from things that do not accord with the institutions' definitions of what we are and what we produce. Death exists in many forms, it exists in the way people assume they are living a great life, a rich luxurious life, a comfortable life, a smart life. It doesn't need to look like death for something to be dead and for someone to be dead. Either we create life or we accept death.

What I call 'revolutionary animism' is an approach towards the material and immaterial world that doesn't seek

to define the distinction between the physical and spiritual experience. Everything is unique without conclusion, and therefore is necessarily co-dependent. Nothing can be numerically valued by something else. How can you sense that you are part of this revolution? Listen to each other without knowing, its materiality can be a touch like light passing through a room.

Mentally and physically ruined, and without people to speak to, I witnessed the triumph of bureaucracy from a distance: the victory of conservative academia and institutionalisation, self-policing and actual heavy repression. Fear takes the form of either the nihilist's apocalyptic, anthropocenic political milieu or the positivist's hyper-humanitarian propaganda. The repressed, devastated radical scenes turn towards reactionary leftism slowly but steadily, in London, New York and Athens. Fear, anxiety, depression pushes them into the trap of the neoliberal paradigm: the comfort zone of capitalism's binaries. Actions become reactions to the state's repression, often named as post- or neo-something (put anything you want after it), so the majority closes up, total and fascist.

I never operated in a group, because I was easily bored by too much socialising: the feeling of suffocation, the density of expectations and the comfort of belonging. There was always a misunderstanding with this: I ended up getting in trouble, and there was no one to defend me, and that creates a lot of suspicion. Many times I had to speak loudly in order to be heard, which I still do because I don't like to have backup, or a support group to create a space for me before I speak or do anything. I want to talk when I want to, without knowing the consequences.

We had the discussion so many times

and you keep on repeating

that this is the worst time

to fall in love

I say you are wrong

but who cares

I hear you are busy

sweaty like a grey rat

making up new explanations

now this is now

this very moment

the moment we are talking

and we are having the conversation

this is the worst time

to fall in love

we had the discussion and I had sex with you

we had sex with three men after you

every night I give birth to millions of babies

who are ghostly, good-looking

looking at me when they depart from me

when all of those babies arrive on Mars

you will still be here on this planet

Two

Did you see, we like I, moving images, signs and postures and gazes and circles for your love, love again and again, love for you, to you, as I observe my desire into you and I follow it until the end without ending, we, we are one and not one but two, two ones, I take you and it is me I take, it is me you have and then you take me and it is you that you like, there is no such thing as two when there is three and four and then suddenly it is one when the neck turns and I see you and I see that I am still here, I will touch you and I will stand here, even if it is an empty room and we are two in this room, walls are crowding, what do you see, two sexes and one at once, it is a hand showing direction of dances, drinks, hunting colours, seduce the night for you, my one, is it two that it is clear, two then, opposite, leaking the fertiliser and the motorbike sounds ugly, annoyed, pretending to have a good time, two, two for good, two as butter in the fridge, bread on the table, I will go, standing until the end without ending, we are not one but two, in love with you my one without you my one only like two you are, you love me two, democratic procedures make us vomit, the leftover bitter chocolate taste in the mouths of all the pedestrian lovers, swinging our arms out of buses and trains, the city pigeons crash into the city windows, grey grass, grey dress, grey little lip, what a fake face, I gave you a pack of cigarettes for your birthday present, you left the office and found solitude in the extra room behind a painting, I want to invent information that makes some kind of nonsense, that you find no interest in anyway, I continue, repeating the same phrases, for you, it is the first time, I will knock at the door and smile with the same smile not because I don't have another smile to give, only because I need to repeat the first time I smiled at you, love, what an asshole, what a nice round asshole, the cheeks are red, sweat occupying curves, lights are brighter, we are passing between cars with drivers watching video games, luggage, language, counting orgasms, one, two, three, ten, wow, break it to pieces, one of one million and I carry no change.

Hi D

Hi D,

Maybe you are right.

If you do something for Adbusters, you can write my name. And you should mention Void Network!!! (this is Tasos talking)

hahaha, g

*

I also continued the text for the General Assembly if you want to take a look. Tasos (my brother) says it was stupid that I told you not to use my name. I am very conflicted, I don't know. Anyway read the text and let me know, maybe you think it's tooo theoretical.

yours, g

*

I thought about this more, and I don't want my name to be in the article. If you please, please don't put my name in anything you write. You can say a crazed person or something like that. I feel very uncomfortable with my name being published or mentioned in any way in this whole thing. You can mention me as 'new mask'.

*

Hi David,

I think if you want to give an account of the history from 2 July until 17 September, and the making of the General Assembly that we all took part in, and you want to mention my name, it would be good to write my whole name and something like artist/anarchist Georgia Sagri. If you mention Greece, I think it would be nice to include the Greek General

Assembly at Syntagma Square and the uprising in Greece as an inspiration, but not connected with my name specifically. I don't want to be mentioned as someone who organised the General Assembly in the first place simply because I am from Greece. I don't identify as the Greek missionary of the GA. The significant thing for me when I organised in New York was how people came together and started talking to each other and sharing ideas rather than having one person tell them what to do ... which was exactly the case on 2 July, the moment we arrived at Bowling Green ... and that's the problem with every GA when there isn't enough space for the process to become something more than simply a place for decision and proposals, and when the space is taken by political parties and organisations.

I will be coming to New York very soon and I will continue participating as much as I can at Zuccotti, but what is important for me right now is the creation of spaces where a couple of people can share ideas and resources and actually do something to change their lives. I am not sure the Zuccotti camp can change anything of our miserable lives unless we see it as a place in which we can actualise our dreams together. That's not really happening yet, and I am sure it's not going to happen. Some people participating in Wall Street only take energy from the metaphorical aspect of it. Perhaps from the nostalgia for some kind of political revival and its demonstration, which comes straight from the 1960s. I am not sure that they want anything else except the metaphor and they have no propositions.

In any case, the important point is that many people are politically present, and they seem to want to do things ... What that will be is going to show up very soon ... when the GA in Wall Street is over.

g

*

yea! All this sounds inspiring. I am so happy the country is waking up and things are starting to move ... I wish I could change my ticket asap but there are many things to be done in Athens as well. I am so happy the International Socialist Organisation has dropped out. We will see what is going to happen in the next few days. What are the next plans for you? Are you planning to go to New York soon? Who is raising the money for Occupy Wall Street and why? How is the money going to be used?

Who is in charge of that? Is there a working group for that? Mass media is still entirely ignoring the occupation??

g

*

D,

We need to listen and be the place where the problems and concerns of local communities are invited in and discussed. We need to allow topics to emerge that are relevant in the US and worldwide right now, rather than impose issues and simply invite 'experts' on issues to talk. We need to actively be the public space, be the freedom of speech and informational flow, and to connect with the demonstrations in Turkey, arrests of Twitter users, political prisoners and hunger strikes in Guantanamo, etc.

Police brutality, the Flatbush riots, and the biggest issue, THE FREEDOM TO ASSEMBLE IN PUBLIC, are very important. I think we can bring these issues in and discuss these all together, in public, plan actions, and further our networks. So something comes out of this.

I am certain I do not want to bring Occupy Wall Street forms into this. I would prefer if this is something new, relaxed and perhaps OWS will naturally come into the discussion, rather than imposing formality and a character onto the week.

If it's OK with you, when institutions want to affirm their power through OWS I want to know beforehand as I personally find it very problematic, and I wouldn't like to get involved in something like that.

In my opinion OWS has become a mannerism: this was my fear from the beginning, preventing things from happening that need to come from the self-governance and self-empowerment of those who don't perceive themselves as activists, organisers and experts. For self-governance to develop further it needs to be brought to the everyday places of the people who participated. Otherwise those who participated in OWS just create another organisation among the millions of organisations that exist in the US, with its own form and characteristics, etc. For many people OWS became a role and another work. So, I am not interested in 'representing' an organisation or a group, but rather to be there as me, Georgia, artist, anarchist, gender pronoun 'them'. If that deal is not clear, I will at least do my best not to become a weirdo representative of OWS.

That would be too creepy to handle.

Bureaucracy tends to stabilise roles and characters, killing the flow and spontaneity of self-organising efforts, which need to come from the bottom without any concern of getting permission from a central committee, or predetermined by any form. The palaeolithic ideas we have about organising via the left-party, union-type form, prevented the General Assembly from being a module for people to come together, talk, listen to each other's issues, and instead created a brand called 'OWS' that then used the General Assembly to solve its own issues of how to protect, expand and promote itself. So the GA became a tool for solving practical issues and not a tool to empower everyone to speak and listen, to educate themselves, to engage with each other and be in public space, to take space via the presence of their body, by giving time to a discussion, to assemble. This attitude of OWS, at some points, blocked the spontaneous efforts to rise up, including

the occupation at Artists Space, the different efforts to get into buildings and create multiple and various kinds of activist-like attitudes, the biggest example being the failure of Mayday 2012, which made everyone miserable. This can be the topic of our week. Maybe the two of us can have a discussion on this and how to move beyond it in the US context.

These are ideas, and I would love to know what you think.

G

Occupy

I am learning a lot from different people about things that are happening in New York and I am so excited to join you all very soon. But I would like to let you know that I am not interested in participating in the art and labour working group in Wall Street or the 'Occupennial'. I read about these groups and their statements. To me they seem like opportunists. It is very important and very significant not to have these people – at least in the beginning – involved in the occupation we are going to do at Artists Space. Please trust me on that, and don't speak about this to anyone. I haven't said anything to anyone either. We will communicate this to people who are close to us (very few and friends) and we will do it in a gentle way, and we can discuss it when we meet. More details about our meeting:

1. I am back in the afternoon on the 13th. I will sleep at Zuccotti from the 13th.
2. I can meet you there if you want, late in the evening. My phone might not work so try to find me, or I will email you as soon as I'm there.
3. We can do the occupation the afternoon of the 20th (exactly at the time that Artists Space closes for the day, I think it is 6 p.m.) and at the moment we do so, we will announce to them that from now on this is an occupation, and hang a big flag of occupation from the window. We will send thousands of emails everywhere and ask every artist to join us. After that, we (me and you and the few that will help) don't need to be there all the time ... so you don't need to worry about your work. You can go in the morning to your work and then return and continue. It would also be good to announce it to your colleagues and they can join us on the weekend as well. Other people and friends should be there as well. This is not an art project and doesn't have authorship, so anyone can be there, not only us. The moment we do this many people will join us and we won't need to be there all the time. Something like what happened with the GA and Wall Street.

4. I am not sure about Godard being the first thing we screen, maybe we'll show all the films of directors we like. We can call friends/artists/filmmakers to present their own works and also make an international call for artists to send their work to be screened and shown there. No selection. Everything will be shown!!!!

5. We need to start writing a text and design the blog which will be up immediately at the moment we do the occupation. We will post images, 'schedules', and everything we do will be on there.

6. Another idea is that we can start an artists' GA and we can have an agenda for artists, the art market, etc. and we can include this in the text we make. I think we must start working on it very, very soon. Tomorrow? I miss you so much.

06.09.2011

Performance study group in Zurich

I am very happy we are all together again. In our first meeting I noticed that some of you are interested in performance art. We are provoked by the use of words such as 'performance', 'gesture', 'performativity', 'body', 'movement', 'action', 'live', 'event', 'activation', to name a few. From the perspective of the art historian RoseLee Goldberg, performance art became accepted in its own right during the 1970s, when art spaces devoted to performance sprang up in major international art centres such as New York and Paris. Museums sponsored festivals, art colleges introduced performance courses and specialist magazines appeared. Goldberg, who was the first to write a substantial history of performance art, claims that the use of performance is split between artists who transform their practices within existing traditions and those who go against the establishment and the art market, indicating new categories outside of it. She makes this analysis of performance using the already existing disciplines of the visual arts, because this is the only tool art history has – opposition. In doing so she positions performance as an event-based product of these existing disciplines (painting, sculpture and so on), participating in an idea of the avant-garde either from the side of the positive (participation by expansion and transformation) or the negative (reaction and establishing new grounds). In perceiving performance through the lens of the binary we effectively regulate performance, missing an important fact, that of its interdisciplinarity and fluidity, which is, in my opinion, the ground on which performance as a medium can be cultivated.

This ground is the subject that cannot be reproduced within the ideology of the visible. A system of implicit assumptions between representational visibility and political power has been the dominant force in cultural theory. Interdisciplinarity is the use and combination of different mediums for the articulation of purpose (motive of a practice). Without performance, artists couldn't pursue interdisciplinary practices. Through performance interdisciplinary

practices exist. You cannot have interdisciplinary artists without performance.

Here you see a work by the artist Carolee Schneemann called 'Interior Scroll', acquired by, and displayed at, the Brooklyn Museum. It is one of the foundational pieces of performance art, combining text and movement, and is a continuation of the artist's question: 'Could a nude woman artist be both image and image-maker?' The first performance of 'Interior Scroll' occurred on 29 August 1975 at an East Hampton, New York art show titled 'Women Here and Now'. Before an audience of mostly women artists, Schneemann entered the performance space fully clothed before undressing, wrapping herself in a white sheet, and climbing atop a long table. She informed the audience that she would be reading from her book, *Cézanne, She Was a Great Painter*, then dropped the sheet and, while wearing an apron, applied paint to her face and body. While reading from her book, she performed a variety of 'action model poses' typical of life-drawing classes. Finally, Schneemann removed the apron and began pulling a small (folded) paper scroll from her vagina while reading it aloud. The text was taken from 'Kitch's Last Meal' (1973–76), the same artist's Super-8 film exploring the life of an artist couple from the viewpoint of their cat. 'How to make a smooth stream of information, a visualisation of this interior knowledge?' she writes about 'Interior Scroll'. Two years later, Schneemann was invited to the 1977 Telluride Film Festival by her friend, the experimental filmmaker Stan Brakhage, to introduce a series of erotic films by women. Upon learning that the programme was titled 'The Erotic Woman', a description that she found limiting and counterproductive, Schneemann decided to once again perform 'Interior Scroll', this time in the context of a film festival: the scroll's words – which recount a conversation between herself and an unnamed 'structuralist filmmaker' who refuses to watch her films – became all the more cutting. The filmmaker chides Schneemann for her

ethereal – and therefore traditionally feminine – use of 'the personal clutter / the persistence of feelings / the hand-touch sensibility / the diaristic indulgence / the painterly mess / the dense gestalt / the primitive techniques' instead of the masculine 'system / the grid / the numerical rational'. While it was assumed that the anonymous 'man' was Schneemann's then partner Anthony McCall, in 1988 Schneemann revealed to the film historian Scott MacDonald that the text was in fact a hidden letter to the film critic Annette Michelson. 'Interior Scroll' was, for Schneemann, a way to 'physicalise the invisible, marginalised, and deeply suppressed history of the vulva, the powerful source of orgasmic pleasure, of birth, of transformation, of menstruation, of maternity, to show that it is not a dead, invisible place'. The performance evolved from a dream in which 'a small figure extracted a text from her vagina that simply said "the knowledge"'. As such, 'Interior Scroll' asserts the womb not only as a site of reproduction, but as a source of thought. By pulling a physical object from an otherwise hidden space, the interior becomes visible, and also vocal. 'I thought of the vagina in many ways – physically, conceptually, as a sculptural form, an architectural referent, the source of sacred knowledge, ecstasy, birth passage, transformation. I saw the vagina as a translucent chamber of which the serpent was an outward model, enlivened by its passage from the visible to the invisible: a spiralled coil ringed with the shape of desire and generative mysteries, with attributes of both female and male sexual powers.' Images of vulvas were more prevalent in palaeolithic caves than images of animals or phalli. While it was originally presumed that these images, along with figures like the Venus of Willendorf, were created by men as manifestations of their desire, it is now believed that they were actually made by women in their own image. Or, as the art historian LeRoy McDermott wrote in *Self-Representation in Upper Paleolithic Female Figurines* (1996): 'As self-portraits of women at different ages of life, these early figurines embodied obstetrical and gynaecological

information and probably signified an advance in women's self-conscious control over the material conditions of their reproductive lives.'

When I say that the centre of my practice is performance it means that I constantly use and combine different disciplines for the purpose of a piece. In order for the merging of disciplines to happen I need a medium that acts as a glue. It is the process and also the moment of activation. Performance is a medium and not an action. Performance is not the event but the means. A performance piece is not produced beforehand to be presented for an 'assumed' audience.

If the piece didn't occur, the medium of performance was never used. Performance doesn't count on a particular tradition, and it doesn't create tradition, because its focus as a field is on destabilising form: freeing form from thinking, putting thought onto the senses and letting the senses move the elements of thinking. The performer is part of those elements, equal to and under the influence of the elements (visible and invisible). Performance is not an on/off action. I need to train, I need to create a routine.

The first exercise is the 'manipulation of time'. Second exercise: repeat what you have done and do it again through the memory of the action you did. How time is perceived within the piece must be different from the viewer's perception of time. Not like slow motion. The time needs to be different. How a performance art piece is prepared differs from the way a dance piece is prepared.

In the performing arts, any event, any play, any dance piece can be called performance, but I do not think many performances could be called dance pieces or theatre plays. And not many performances within performing arts could be analysed using the terms of visual arts. With this at stake it is quite difficult for artists, historians, academics and viewers to perceive performance as a medium, because we have already categorised the practices of artists who do performance either in relation to practices that they are antagonistic to, or

that they are already within. As an artist if you want to be free from tradition, if you want to create a new field of thought and perception, you must combine disciplines in such a way that in the moment of their connection they are not understood anymore within the restraints of an already existing heritage, but from the results of their merging. That is why I believe that performance is the medium of our times.

Drawing is a routine of preparation. During no-thinking, sometimes shapes and then something else start to appear; something clearer appears that reminds me of something specific; some words, and then the drawing is over.

If the fear of nothingness and of failure doesn't disappear then it is difficult to draw even a little dot. The skill here is not about how you represent something, or how you mimic something, but how you are able to abandon the precondition of the moment itself.

The 'liberated' character of our time, with all its allure, its false understanding of the situation, its fear of death, its emasculated love, its irresponsibility, its inability to grieve, creates subjects of consumption totally compliant to social rules.

I draw a lot to train myself not to be afraid of falling into a situation of no control. It is an improvisational training tool marking qualities of tempo. Fears appear and are imprinted on paper, better on paper than in my mind. I am ready now.

The body is an image that exists in many moments at the same time in parallel to each other. Interruption of 'the image' over and over again is not easy to process, it takes many attempts, and it takes mental time in order to understand what it is that you are seeing. Regardless of whether what you perceive is right or wrong. It takes time because the image is not acting as an advertisement. The basic principle of advertising is to be quick, direct and understood. The viewer must understand what he is seeing in seconds. Everything is done in order to remove ambiguity or to use ambiguity in such a way that it can only lead the viewer to one, single conclusion. For example, 'This is ketchup and it is for you'. Therefore if

we can manage to change the way that we think about what an image is against all the odds, let's call it 'representational syndrome', perhaps we can leave the given factor of 'space' and move into the given factor of 'time'.

Here you see a work I made in 2018 called 'Semiotics of the Household'. It is mid-afternoon on Hester Street in the Lower East Side of Manhattan. This is the time when the majority of passers-by are returning from work, tired from the overuse of screens, running for last-minute groceries, hanging out to check shop windows or strolling through galleries. I took a packed wheeled suitcase, containing the bare essentials needed to travel and to exist in the US, as a desta-bilised subject. The familiar sound of the suitcase's wheels on the pavement signals precarity, but also – in Lower East Side Manhattan as in the centre of Athens – triggers the annoy-ance of tourism, Airbnb, extraction of the everyday for the sake of packaged experiences. I insist on throwing the suit-case into the street, very purposefully, outside the entrance to the gallery where my exhibition is hanging. Where the suitcase lands marks where the suitcase will be opened up. I unzip the suitcase, unpack and fold the contents carefully across the street. The personal belongings (underwear, trou-sers, T-shirts, a dress, sanitary products, passport) set a line, a barricade across the street from pavement to pavement. The headlights from the cars make the details dramatic, I con-tinue playing with the theatricality of the upset drivers, their high-pitched horns. Insisting on the precarity of this suitcase, of the timing it contains, I push it against the precondition of the street I described, making the precondition light up. When I re-pack the suitcase, I let the pause hang, everything around is in slow motion and I raise the suitcase like pressing the slow-motion button of the entire scene, I lift it up high as a totem of the situation and without a second thought throw it down to begin again. Wherever it fell I opened the zip and unpacked my belongings across the street (toothbrush, note-books), drawing a line to connect the pavements, making the

invisible and the intimate a place. The performance lasted more than ninety minutes. Each loop has its own attractions, smells, senses, sounds, protagonists. A person screams at me, asking if what I am doing is art, the scared parent runs with their kids to avoid the scene, the cabs pass over my stuff crushing some cosmetics, a skater ollies the line, showing off, some familiar faces try to avoid eye contact with me, a garbage truck pushes to keep to the clock, and the workers suspend their labour until I have cleared the street on my own. Customers complain, shop-owners complain, there is a sense of the grotesque, or parody as in a musical. I hold the suitcase and make it my partner, my support. Instead of speaking I whistle – a consistent tool – to block the self-policing that can take over the work, and to let go of fear, to allow the joy of the movements and the differences which emerge every time a repetition expands, in each second of the reality. The loop began when I threw the suitcase for the first time into the street. I moved gradually away from the scene, continuing to throw my suitcase up the street, suggesting that the performance is coming to its end, but the performance was already done. Now the police arrive, apply handcuffs and ask if I have taken my medication. On the pavements bodies are falling apart. Some bodies turn into recording devices, some walk by like shadows, others keep a safe distance and those who are still with the tempo of the work gather again and realise they are witnesses. I was not arrested because of them. Their reality was required. That is why the work is not an image, it is actual and it is real. It cannot be optical because it is real. The bodies become active, they have time to think, they do not become better viewers but sensitive active members of a social fabric that takes place within the sites of their presence's existence. What is recovered are the social sentiments that can emerge within non-systemic, structural formats.

The performance does not happen for the viewer, therefore we must set aside any theory of gaze here. The performance does not happen in order that I can show something

to an audience. I am not showing something because I do not possess it. I think that the performance not being for the audience is very important. It is not a representation. And this is a very big difference with theatre and dance. They are always representations. And that is also why they have the concept of 'rehearsal'.

If there is a script that means I am depending on something that is already predetermined. And there cannot be a predetermined contract. What you can do is prepare. This is what the everyday training is about. So that there is a part that happens without knowing how you will use it.

Dancers are desirable when they dance and need to be because they must always signify a stable point. In a performance piece the body does not indicate a steady point but exactly that which is not stable, is already gone. If dance deals with the representation of what we call one designated moment, that means that it shows you something that is already in the past. It is something that looks like it is alive but it is dead. Performance allows something that is already dead to be alive, to be visible. It is aware of the fact that it is already dead, but it lives and remains alive. This is where the interest lies, and that's why practise is crucial. Because you cannot exist in the unknown without being aware of the mortality of the body. The mortality of the body is the material that you activate through practise.

How do you want us to meet?

We will perpetualise ourselves

Borrowed name

And down the street

Dracularisation

My dearest friend

It is a fact

It is silk hunger

All the way from the dead sea

How we will find food at this time of year?

The blood is not enough for both of us

Me against me

The only solution

Dig the skin

Create a new digital brand

The

The

The

sniffing

nose

makes the pretty girl shiver

all of your knowledge

of evolution

gone

old shitty man

why do you ask money

it is cold

no one will give an eye

you smell bad

the white filthy

dust

around your toe

the plastic bags instead of socks

let's vomit together

parade of vomits

on the track

to Manhattan

and soda

One

I was not offended when you looked at me and I realised there was no one in my place to look back at you. I comprehend. Seriously, I have strange feelings about the different wars that are going on in the universe and I am ready to take some action, very serious action. No jokes. This is not some kind of whatever mechanism you find in a shopping mall. Flowers in the middle of the unspeakable, caramelised news behind curtains in front of other curtains, and all of them become layers of some kind of onion that all my friends talk about; it's over for my cup of tea. It is empty talk. We got used to talking with our fingers and pretending that if I wink, you will get what I mean, but I want you to get something and if you think this is a problem then you have an issue, which a dentist can take care of. First of all it is about the dogs. Something went wrong with the dogs in the mastermind cities and all of them have their own leashes. The parks are brighter, too many lights to keep any secrets, smoking is not permitted and all of us have one particular something to take care of and especially ourselves. Then, I missed all my friends at a well-established university. I'm bored and I don't know why. I never have enough money to go up or down anywhere. The issue here is that no one, I'm telling you no one, is going to take care of you. Just think about it when you look at me.

Occupy

Hi, this is a text I drafted and have been sending as a response to listservs and individuals that have been distributing calls for federating and 'organising' assemblies, mostly along geographical lines (national above regional above local). I thought it might be interesting to share. Anyone is free to use, redistribute, edit and so on. This exists as something of a cautionary open letter in response to all the calls to federate, centralise, or otherwise provide a structure for the proliferating neighbourhood-, workplace-, identity-based assemblies. The series of calls, initiated from all manner of areas and with all manner of intentions, to attempt to 'coordinate' or structure the now numerous assemblies that exist across our boroughs, our city, and our nation, seem to come from a sensible place, but represent a moment of extreme danger for the occupation movement and its affinities. I hope that as this discussion moves forward, it will be kept in mind that the assemblies that many are trying to integrate into their days are not homogenous, nor do they serve a constituency. The very foundation of the popular assembly, if it is to be potent and resistant to recuperation, lies in defying all concepts of representation and 'legitimacy' of fetishised processes and communication. In refusing representation, we refuse all leaders, all hierarchy. We experiment with the complete inversion of politics as forced on us by state and capital.

While one attempts, innocently perhaps, to build logistical structures for coordination and communication it is too easy to create central committees, authoritative bodies and privileged politicians. Assemblies exist as spatial and temporal bodies. They are the opposite of organisations, which must justify and perpetuate their own existence, and are composed of fixed and delineated bodies. The assembly is composed of participants that are constantly in flux, its nature and tone are accountable to the present moment, it can be manifested and dispersed at any time. The assembly is anything but permanence, subjugation to form, or identity. It cannot and will not be a chapter, it cannot have

representatives, and its power cannot be delegated. Zuccotti, for example, saw a General Assembly formed as a response to occupation, the seizure and reclamation of a park. Its assembly came together to discuss and delineate the needs of its occupiers. It, ideally and when unconstrained, is the poetics of the space, continuous and passionate activity. Now, a GA hangs in the ether, corresponding neither to a locality, nor to an occupation. Out of the space and into the vapour. Its authority becomes detached from a particular space and time, making mandates and enforcing processes for no one and everyone. This ambiguous power is the power that practically asks for recuperation, and is a power readily seized upon by bureaucrats, leaders and politicians who want so much to speak for a mass without having to deal with the complexity, unknown possibility, and thus the dissensus innate in mixed desires and fluctuating bodies.

The travesty of the spokescouncil shows where such a politician's will leads. The spokescouncil is the ridiculous playing out of the organisational mentality, assigning itself special powers based on conceptions of logistical needs around a park occupation that does not exist. With voting and financial power, a sanitation working group desperately brings gloves and Windex wherever it can to prove its con-tinued existence and maintain its apparent necessity to a supreme body. Bureaucracy can wield a sponge or an army, it doesn't matter, it will do whatever it can to resist dissolution. Principled, philosophical, political ground is cleared to make way for manufactured purpose and dominion. We should remember that the assemblies are subjugated to no par-ticular form, that no social upheaval can exist as a brand or franchise, and that communication already occurs regularly and steadily between eager participants and the fluctuating spaces themselves. Any 'decision-making body' created as an umbrella for local, autonomous assemblies will constitute a de facto higher power that will destroy all creative capacity coming from below. We are here to undercut all authority

and share our creativity and experimentation. Anyone who wants to guide, to lead, to organise or 'recruit' others for their own use or the perceived use of a movement, has missed the potency of this upheaval, and frankly can do nothing but constrain and eliminate it.

All structures must be exclusively coordinating and horizontal, and the concept of legitimacy or brand recognition should be abolished absolutely. We want everything for everyone. We are history in motion.

23.12.2011

Occupy

If we think of a life without capitalism and state then we will be able to attack the idea of a job, and fully find each other in politics, education and social service with freedom and equality for all. I endorse any steps on the part of the student movement to engage in socio-political issues beyond the student identity. I do not agree on focusing on 'job security' and the overindulged 1848 demand for 'the right to work' and public education. I fully understand which ideologies this language comes from, it is a trophy of the left that has become a trophy of neoliberalism. There is much work we need to do in order to shift the language of the current historical moment, in which the attack on the economic system and the state remain together and not separated. If the seriousness of the situation is not clear, a shift of one word can't change anything. What is important for a bunch of us to understand is that we don't want to replace the union leaders, the expert organisers, or the 'makers' of the student movement. What is great, and what we are seeing every day in every corner of the world, is that people are aware of the political and economic games played on their backs. They recognise that the political situation – called democracy, dictatorship, oligarchy, etc. – is fabricated in favour of capitalism's monstrosity and its expansion into every inch, every pore of our lives. Privatisation expands to perceive and calculate our lives as numbers, it does the same with water, plants, seeds, animals and DNA; if we are not able to talk about these issues in connection to the humiliation of the worker, the student and the members of every profession, how can we expand our understanding of work without the power relations it entails? If we can't speak about the demolishing of money then how are we able to speak about life, other than as mere survival? Words only come from a place of negotiation. When we call people the 'broader' audience, we are speaking and doing as politicians, lawyers, bureaucrats, managers, unions and organisers do; our words must come from mouths which are among the people we

are writing our texts with. Not for, but with. Seize the empty words, and speak about life rather than death.

25.12.2012

History

History is when people come together, and that's the moment of the creation of a narrative which is doomed to be banished along with the dead bodies and the rotten memories of the singularities who experienced that force of feeling. The commentary: ethnographers, historians, experts, academics and all kinds of critics vomit the words of the people as theories, analysis, art and give stories to comfort us at the death of history, the death of the history of the moment of the people's coming together. Now something looks like it is shifting, slowly but very strongly. In the last decade there has been a multiplicity and variety in the way people come together. There is not a single way that people want to organise, so there can't be one event that will signify any final accomplishment, so the stories are fewer than the history that people are creating. Their actual history is posted, distributed, spoken, activated and it is spreading faster and more directly. The banality of the stories of the experts are as relevant as a bottle of shampoo that will be used for a month. It is the desire of the people to speak, to self-organise, to activate and create life in their own ways, with their own capacities, together, and to make a liveable life without waiting for the permission and false affirmations of political, ideological, economic and aesthetic masters. This history is stronger than stories. The death of the virtuoso, the leader, the genius, is here, and the death of the author is becoming an actual fact, and I am so glad.

While I say 'I am an artist' in order to pay my rent, the actual work is to be able – at the same time – to expose my needs and continue to speak my desire: I do want to live beyond the current oppressive economic, political and social systems, and to think that this is something that can happen now, today, with you. How would it be to simply act without considering the state? There can be actions that are not reactions to regulations. How would it be, to be a lover of one, two, three, and everyone? What if marriage wasn't a right but something people do for fun? Kids would need more than

two parents, a network of friends, houses and schools that are open to all. Then it is everything for everyone. How would life be without the de facto of property being only private property? How would it look to walk without being afraid, with no feeling of exclusion or being watched? How would it be, not to be gender specific? The work is to call, seduce and look for my community and to be part of the political, emotional, sexual and intellectual movements of my time, with all the contradictions, fights, battles, love and intensities that this act of searching implies.

18.07.2013

AAA

This document was written by participants of the three past open anti-authoritarian, anarchist, autonomist (AAA) assemblies held in NYC. Particularly, after the last meeting we saw that the open assembly was used for logistics instead of analysis, and for the purpose of making decisions instead of broadening and discussing the social issues and struggles that are currently emerging in thousands of locations across the city. We understand that through our participation we will transform the character and the tone of the assembly and that the above will be discussed and expanded in the coming assembly.

- AAA is not a proposal-based or decision-making body. It is an open forum that doesn't require expertise in any process-based form.
- AAA endeavours to be a 'traditional' or known occurrence; a consistent forum that does not require calls or special impetus.
- AAA is a space for political discussion and context. The discussion should be what lays the ground for, informs and broadens the possibility of actions. Therefore it is not a space for planning, logistical discussion or recruitment.
- AAA should address discussion themes that are made known beforehand (themes can be delineated for the next meeting at the conclusion of each assembly).
- AAA will forever be entirely open to everyone who is in alliance with the basic anti-authoritarian, anarchist, autonomist perspectives.
- AAA should encourage autonomous actions/comrades and be present and support social struggles and activity and the possibilities that they create.
- AAA is a space for the creation of analysis, of texts and the understanding of the multiplicity of anarchist positions.
- AAA is an open space. Each participant should be aware of the oppressive and paralysing forms of security, surveillance and police culture; but those understandings should not prevent them or others practising, speaking or organising freely.

Occupy

An attempt to agree on five simple messages for outreach by the General Assembly of the people of NYC:

1. Both political parties govern in the name of the 1% of Americans who have received pretty much all the proceeds of economic growth, who are the only people completely recovered from the 2008 recession, who control the political system, who control almost all financial wealth. So if both parties represent the 1%, we are among the 99% whose lives are essentially left out of the equation.

2. Wall Street created the economic crisis, and there has been no prosecution. Politicians are making we, the people, pay for the fraud because they don't represent us, they represent Wall Street. If we want to fix this, we have to create a movement of the people and kick banksters and their servants out of power.

3. Wall Street and its government are working together to eliminate our jobs and cut our wages. It's time to stand up for our rights and for justice. Occupy Wall Street on 17 September.

4. If you don't like the government, be the government. Join the NYC General Assembly.

5. This isn't left versus right, it isn't north versus south, it's Wall Street versus America (right now, they're winning).

Creep

I felt bad for you

Response to Occupy Wall Street's art and labour working group

The ministry of culture of the former Soviet Union was the worst and most brutal of that state's committees. It operated as the art police, and against any group or individual's attempt to bring forth anything that wasn't controlled by it. This repressive behaviour is very clearly demonstrated by the art and labour working group of Occupy Wall Street, and by OWS itself, since the beginning of the occupation at 38 Greene Street (Artists Space). The wish for centralisation and policing is now clear through the denunciation of an autonomous act beyond the art and labour committee of OWS. The action was, of course, immediately named as violent because it wasn't in favour or in the context of what OWS permits. Some of the participants of the 38 Greene Street occupation had to deal with constant attempts of OWS group and committee members to impose certain ways and behaviours of how an assembly and an occupation 'needs' to take place, while also being manipulated by the staff and directors of Artists Space. The supposedly 'professional' facilitators only came to the space to undermine and disturb the free forms and processes of an occupation that was announced as open and without barricades from its beginning. I, along with many of those who participated in the occupation, am not part of any group. The group name 'Take Artists Space' was created by the Artists Space executive director and his staff to undermine us. The occupation was not an art project, there was no leader and there wasn't a given bureaucratic procedure, frame or line for how to behave. The twenty-eight-hour occupation made even clearer how important it is for a person to live and act on their own and together with others. Occupation is a political act that opens space for various possibilities of life and political expression. There is no end to the struggles and initiatives of the people. The occupation at 38 Greene Street is only the beginning, and any group or individual that means and

tries to undermine people's intentions finds me, and many of us, on the other side.

27.10.2011

Another response to Occupy Wall Street's art and labour working group

... There's also some confusion about the whole thing on Facebook's Occupennial group and one person writes: '... for the record OWS didn't "take" Artists Space, it was invited, even treated to free pizza and beer.'

If you want to occupy something people, how about a blue-chip gallery or an auction house? Maybe a politician's office who is infamous for not supporting the arts or cutting arts funding?

I'm not the only one confused, Andrew Russeth is too, so is Steve Kaplan and Paddy Johnson seems just as befuddled, though I think Turco says it best: 'Perhaps Georgia Sangri [sic] and her merry band of self-described anarchists should start anew by occupying the Anthony Reynolds Gallery, a posh art space in London that still sells her work.'

— Hrag Vartanian, 'Occupying Art Things Has Officially Jumped the Shark', *Hyperallergic*, 24 October 2011

Maybe we can say that a lot of people participating in the various OWS working groups thought of the General Assembly as a decision-making body, and the occupation as a political organisation, or in better words a full-time job. For these 'serious' organisers and professional activists of the working groups it was the occupiers who created the practical problems, and by extension threatened the movement, because they were less predictable and less controllable than the members of working groups, who had a specific set of tasks to follow. This was one of the reasons why the General Assembly became more bureaucratic with a set of rule-keepers for the process.

The rhetoric against the GA was created by the same working group that initiated the facilitation roles. This group never presented the conversation in a public discussion. Instead of transforming the GA, the group produced a new model named a spokescouncil, inviting members to meet and discuss matters behind closed doors, in order to come

up with a model that could provide a more accurate structure and a faster function for decision-making.

From the start the conflict, which is ongoing, was over the character of the GA. In my opinion the GA is not a decision-making body, and consensus is not voting. The GA was treated in a certain manner since the occupation happened only because the working groups and the occupiers used the GA mostly to approve practical issues instead of turning the GA into a space for discussion, political debates and thematic analysis. This is a symptom that expanded; it is recreated by a particular facilitation group and it manifests in the mannerisms we all have to deal with when we call a GA.

Let's not forget that although the call came from a magazine and was an advertisement and we were not involved in its preparation, the organising for the action on 17 September was primarily based on the calling of a GA, and the occupation wouldn't have happened without this. The GA expanded and became the occupation, not the reverse. That's exactly what happened in Egypt, in Athens, in Spain, and that's what happened in New York. Many were sceptical about the effect of the GA, and even in the immediate aftermath of its initiation they were watching from afar, expecting it to fail even before 17 September. When the day of the action arrived and the occupation happened they appeared again and they started to participate like they didn't know how this action took place, looking at everything with a sort of exotic eye. After the Brooklyn Bridge events a large number of radicals stopped going to the park. Even those who had been part of the creation of the GA since August started making critiques from afar, in small groups and specific closed meetings, refusing to bring their ideas and opinions to the GA.

Those comrades who left and didn't come back to work on the process and the transformation of anything are the ones who will always play the same role, even if the revolution is on their doorstep. They criticise because they are afraid to make mistakes, or they are afraid to do something

that will actually have a social effect, beyond to their hidden groups and radical personas. The occupation movement did shift our lives, not only in the US but everywhere, and this is more crucial than all of the above.

We have met many who identify as part of the occupation movement, and this is something we created as anarchists in New York from day one, when we hijacked a rally and opened space for forty people to speak with each other and organise the first GA at Bowling Green. Since that moment no one said 'do nothing', everyone says we must do more and be everywhere and continue no matter what. We can't continue perceiving ourselves as outsiders because we are not. We are not experts or more radical than anyone else anymore, because the whole world is shifting, becoming anarchic. How many times in our lives will we have the chance to be part of a social revolution?

I believe only once. Attack! This is our time. We are history in motion.

Another

I want to learn all the names of the flowers

All the names of the birds

And the sea's waves

All her secret forms

I want to learn how to cross my fingers

How to split the hand in the middle

I will leave my country alone

I will learn another language

And I will dream

Dreams of another

Conflict

I was not the leader of anything and my name was not related to any action, even if I was part of it. It seemed, though, that for those who gave my name to the press, there wasn't any question. They assumed that because I am an artist everything I do must be related to an artwork. That particular assumption was clearly fabricated to undermine the efforts of the collective action, and also to spoil any possibility of the participants' ideas transforming the banality of an art institution, especially in an urgent historical moment, October 2011, while the Occupy movement was growing in New York. For me it is still extremely sad that I am approached to share my thoughts about the occupation not as a participant but as a creator, a leader, the author, meaning that as an artist it is impossible to just participate in an action without having the identity of artist stuck to me: I can't be in an event with just my name, physical characteristics, capacities, sex, and experiences. It seems that for the art world today there is no space for people, but only for those whose main motive is to fabricate a particular art avatar, a logo, a brand called artwork, artist, curator, art critic, etc. I find this phenomenon interesting to contemplate ... In order to do the Artists Space occupation as an art project, basically, I would have had to do it as a 'political' artist with the criticality, the framework, and the permission of the institution, to excuse myself from the social struggles and to provide the representation. I wasn't there only as an artist, and the occupation definitely wasn't an art project. What compelled me to be a participant in this event was that, first of all, I had to be there. I had to be present. Certainly, presentation is something I am very interested in, and if that interest made me a participant, I never denied it ... The standardisation of identity is the way that the art business functions. And I would say this standardisation of identity is what happened with the Artists Space occupation in New York.

General Assembly

To me the powers of the General Assembly are undefined. What is it really supposed to be or do? I'm not comfortable with conceiving of it as a 'governing body'. Its declarations and resolutions might have a certain moral authority (or not), but no one is in fact bound by its decisions, nor should they be. The GA could probably endorse and coordinate actions for a city-wide general strike. It can compile and distribute information, advise, and provide a forum for discussion. The one area where the GA should perhaps have firmer powers is in how the camp itself is organised. But perhaps even here it should only be the campers themselves who make the decisions? And most of this day-to-day running of the camp can be done informally or by working groups.

So I see the GA as having very limited functions. On the other hand, the GA (once taken over by the finance working group) unavoidably has immense power because of the huge fund of money that exists. In my experience there's a strong tendency on the part of the finance working group to try and allocate funds to the indefinite maintenance and building-up of the camp. In my view this is almost certainly short-sighted and will lead to stagnation, reinforcing the tendency to treat Zuccotti as a mini-state or outdoor hippie commune. There is value in having a self-organised camp in a symbolic area, challenging and embarrassing the powers that be, but it is not the end goal of the movement in my opinion.

Now it seems the working group as a structure, and/or the spokescouncil they're forming, wants to control this fund and the power that goes with it. This seems very dangerous, since, at least for now, if I'm not mistaken, the GA can at least override the finance working group. Someone correct me if I'm wrong.

Zuccotti is only of interest to me as part of a much broader (global) anti-capitalist movement that is constantly expanding, escalating, and radicalising people. So, for example, recent events in Oakland have superseded anything happening in Manhattan.

Similarly, as this is such a huge, complex movement, with an emphasis on including voices, it seems strange to try and define who is 'in' or 'out', who is a 'real occupier' or whatever. People should have a reasonable expectation of personal safety at Zuccotti, and, for example, physically dangerous, racist or extreme right-wing elements, or governmental authorities, should be excluded. But there's little point in trying to police the space beyond that. It was a public park before all this, and anyone was allowed to be there: are we going to be less inclusive than the city government? I think the oppressed and non-conforming should be at the heart of the movement. Feeding one homeless person in the context of a 'liberated zone' is probably more important than providing a platform for a hundred middle-class 'activists'.

Finally, I think democracy should not be conflated with voting and making collective decisions. In the current context, a disruptive march or a building takeover could be more 'democratic' – increasing the power or potential power of the people – than reaching consensus on proposal X, whatever that might be.

Performance is a medium

What do we understand when we hear the word performance? First we have to admit that there is a great deal of confusion with the use of the word itself. There are diverse disciplines using the term 'performance', but there is still ambiguity about the term in the field of visual arts. The literal use of the word comes from the industrial revolution, when there was a need to describe the 'performance of a product'; the 'performance of a labourer' during work; and the quality of the 'performance of a machine'. Out of this custom the word began to be used by critics to describe the performance of an actor, dancer or musician within the specific and limited duration of a spectacle. The next-clearest word we could give for an actor's performance is execution, and the evaluation is made after the performance is completed. This evaluation is not possible without a convention of measurement to determine which performance is better than another. The evaluation is cultivated by the institution that holds the responsibility of offering time and capital so that the performance can take place and the performer be paid for its existence. In this case any performance that is not strictly connected with an institution doesn't count as production because it fails to anchor itself within the parameters of capitalism's wage relations. But in the case of performance there is neither an object to be exchanged nor a service to be provided. So what does it mean for a performance not to be mediated or 'provided' by an art institution?

In the period of industrialisation (which was interrupted by but continued during the first and second world wars) and during the shift to industrial automation (in the Fordist period) we find the first socio-political milestone, at which performance is no longer only about a worker's performance or the execution of the artist, but refers to the actual organisation and use of time of a subject throughout his day. Time is structured within certain timeframes of social establishment, within the time limitations of a presentation – a play, a concert, etc. – and time also occurs independently through the

capabilities of the structural elements, materials and individual parameters which in some circumstances are the frame for the development and presentation itself. The construction of identity, empowerment and gender equality refers to the organisation of space and time in which each individual and collective decides how an act, gesture or movement may happen to appear. Right at these moments of social mutation, we can see clearly the difference between what representation is for performing arts and what representation is for performance.

As it is widely known, performance took its equal place in the visual arts with the launch of the term 'performance art' by RoseLee Goldberg in 1979, when the first art history book devoted to performance was published. The title of Goldberg's book in its first edition was *Performance: Live Art, 1909 to the Present*; it was later altered to *Performance Art: From Futurism to the Present*. Although Goldberg's analysis provides us with ways to navigate the complexities of the medium, with its long and sometimes unknown histories, the moment of the book's publication cannot be dismissed, and neither can the function of its premise. The end of the 1970s was the moment when performance as a medium, by now practised by many artists, demanded its establishment within the art world and the art market. As more artists were doing performance, the demand to historicise it increased, thus prompting art institutions to present and archive performance art.

In the foreword to her book, Goldberg writes: 'For artists did not merely use performance as a means to attract publicity to themselves. Performance has been considered as a way of bringing to life the many formal and conceptual ideas on which the making of art is based. Live gestures have constantly been used as a weapon against the conventions of established art.' Here we are presented with the narrative that still dominates the history of performance art and positions it merely as a 'live gesture', and also characterises the medium

as a 'reaction'. This art historical account limits our under-
standing of what performance is, how a performance can be
prepared, and what distinguishes it from a theatrical, musical
or dance performance. Furthermore, Goldberg's definition is
product based, failing to give accountability to the process of
what it means to create artworks whose core medium is per-
formance. She constrains performance either to the heroic
act of an individual artist or the turning point of an art move-
ment, which only takes place in the already existing medi-
ums of visual arts (painting and sculpture), and in the existing
performing arts (theatre, music and dance). For Goldberg,
performing arts and visual arts collide through performance,
but it is not clear what makes performance an equal of other
visual arts mediums. If we want to perceive performance as a
medium, rather than simply as a 'live gesture' or a 'moment',
then one of its characteristics is that of connectivity.

To paraphrase the director, anthropologist and art
historian Richard Schechner, founder of the the NYU Tisch
School of the Arts' department of performance studies, in an
interview from 2001 titled 'What is Performance Studies?':
everything that exists but specifically everything that exists
and does something, not just human beings but any living
organism that moves, produces action, that is performance.
If you exist and do something and you present it, if you show
what you do, that is performance, if you do something with
a purpose, for example to make someone laugh then you do
a performance. When you cross the street this is something
that you normally do, but if you cross the road and someone
is filming you this movement which is usually a simple move
has an extra responsibility and purpose, that is to make a few
seconds of film, therefore you are performing.

For artists, how one crosses the road, how this action was
recorded and how it is included in a film is important; how this
movement and its recording can fit in and feed the medium
of performance itself, and how it participates in the dis-
course of visual arts and humanities in general is important.

Performance studies establishes the necessity to analyse and study performance art as a field. For Schechner there are many different methods, ways and reasons, many traditions, experiences and backgrounds, that urge living organisms to do performance: thus there are many ways of analysing them that then produce cultural and intellectual knowledge. In this case performance becomes a concept rather than a medium. Artists, on the other hand, are concerned with the thing itself, with its production and creation. Production in practice and in theory has long been separated. In visual arts production has become a canon: 1. art production happens mostly in the studio; 2. display happens at the indicated art spaces that are the only places of validation for the artwork to be present and for art to connect to the public; and 3. distribution of art happens through the same channels as luxury products. For humanities production happens through the analysis of: 1. the output of an individual; 2. the events that mark historical moments; and 3. the mechanisms of exchange. My concern is that neither Goldberg's nor Schechner's theories allow us to understand performance as a medium, because performance cannot be settled in the canon of visual arts nor be given the attributes of a concept, exactly because performance is engaged with the notion of transformation, and in particular with how production is transformed within an artist's practice. Performance as a medium hovers, its production takes shape inside the changes of how we experience the world, and how we want to live in it.

In 2000 the author and art historian Lea Vergine proposes a puzzling characteristic of artists who do performance in her book *Body Art and Performance*: 'As the basis of Body Art and of all of the other operations presented in this book, one can discover the unsatisfied need for a love that extends itself without limit in time … the need for what is called *primary love*. This is what gives this art its dimension of inevitable delusion and failure. This unobtained love is what transforms itself into the aggressivity that is typical of all of

these actions, events, photo-sequences and performances.' Almost the same, but much more profoundly, public art and interactive art are described using the framework of 'love' by the art historian Claire Bishop in a 2006 article on social art: 'The discursive criteria of socially engaged art are, at present, drawn from a tacit analogy between anti-capitalism and the Christian "good soul".' These psychological, socio-political and religious attributes that are thrown around to describe artists' work are simply a lack of patience in categorising performance as a medium. And why is this? Because art history uses the given analytical tool of dichotomy to characterise techniques and knowledges of the body, producing the familiar and unhelpful split of material and immaterial, cognitive and affective, object-based and time-based, and so on. Just like reproductive labour, performance has been categorised as immaterial production. Artists whose main practice is performance have been used to maintain, create surplus value, increase visitor numbers for the art institutions, and are rarely paid for their work, becoming valueless in the art market and the economy of 'objects'. But since the art institutions are turning into corporate entities, mostly seeking recognition and public power, artists who are able to resist these developments continue to disregard their own precarity and cooperate perfectly with the mechanisms of their use value. They continue, together with institutions, the violence of this dichotomy, making use of the same oppressive mechanisms that women have been faced with, always being classed as those who provide reproductive labour.

As activist and scholar Silvia Federici points out: 'In *Caliban and the Witch* (2004), I have argued that the "historic battle" that capitalism has waged against the body stemmed from a new political perspective positing work as the main source of accumulation, thus conceiving the body as *the condition of existence of labour power* and the main element of resistance to its expenditure. Hence the rise of "biopolitics", intended however not as a generic "management of life" but

as a process that historically has required constant social, technological innovations and the destruction of all forms of life not compatible with the capitalist organisation of work.' But art practice is not work and performance is not a service. Performance is a visual arts medium and the body is in the service of this medium. If performance is a medium, the body does not execute a score (institution), it allows itself to be taken over by conditions. So performance as a medium is an intervention, like a pharmakon, that radically modifies the functioning of the body, inaugurating a new relationship with representation. For the first time in the history of the visual arts, performance makes the tool be the medium: the medium is a (self-)claim and not a fixed function. Performance modifies the way we understand production and the functioning of the body, exactly as the pharmakon does the body. Thus performance is used by artists who do not make properties – they are not making art, they are doing art – and by artists who do not aim to capture and extract but give, change, and make an impact.

Performance as a medium acts as a glue to other media, arts and sciences. It connects and mutates them, it is able to produce new terminologies and ways we can make art and participate with material. There is no studio, but spaces, places and techniques of openness, no reaction or methodology but a constant practice, a play. It is a devotion to different rhythms, their study and creation. The practice of care of the self and others is performance's hybrid nature. Performance nourishes where there is a break in the genres of art-making, and proposes varied ways of self-organisation with which artists can present, reconstruct, document and preserve their works. This is how performance is capable of appropriating the institutional gaps in favour of the public, rather than becoming a tool of leverage for the institutions. It is exactly here that it differs from the convictions of the performing arts, that action is for the sake of presentation only, and work points towards a final production. Since the performing arts

have always been part of the establishment, of the status quo, of the institutional framework without being able to transform it; even if the form is shifting, the framework is impossible to change. This is because the performing arts (theatre, music, dance) are inventions of power and capital for the transformation of the body, the body being conceived as the main source of labour power.

The theorist Pepi Rigopoulou writes in her 2003 book *The Body: From Supplication to Threat* (as yet untranslated in English): 'the greatest strength of performance lies in its ability to absorb elements from the everyday, by simply denigrating them and recording them. Through these elements, high and low art, high and folk cultures, science and philosophy coexist.' However, since the turn of the twentieth century these hierarchies and categories have no longer been used by visual artists. There is no distinction between the role of the performer and the producer of a work, between the composer and the performer. It is limiting to make categories in the moments of art's history when an established genre is broken open by artists. It is limiting to generalise when artists demand a leap into the confines of the media they are already using. The process of writing about the connecting force between media is different from writing about what fragments them. The body as a medium is crucial in our contemporary culture. This is what performance does: it allows us to form active, analytical tools in our societies.

Re: 'Dynamis': Athens + Kassel

I really don't understand why you are bringing up the area of Exarcheia, a place you live, had your office, as an issue in Athens today, two days before the performance starts and after selecting the place yourself for my piece nine months ago, exactly because of the six-day 24/7 duration of the performance.

The area is in a city I am from. I was actually born here in Athens and lived here for many years before going to study and live in New York. I had my studio and apartment for a couple of years at Exarcheia, I have friends in this area, my family is involved in radical politics and my current knowledge says that there won't be any issues. You trust the judgement of Christoph, with whom I haven't talked about my work since November 2016, and the documenta team, who have been to cafes and restaurants in Exarcheia, or those who are in Athens to work on documenta, more than mine.

There is not going to be any problem. We have said that many times. The piece is taking place in Athens and in Kassel at the same time. The appointed venues that you selected yourself for my piece in consideration of the 24/7 performance are 5 Tositsa Street and the Hansa-Haus.

Do you think I was asking for this mess and this insane behaviour I am dealing with now from you? No. Do you think I am happy about this? No.

There is no need to antagonise me just because you see me here as the punchbag for all the organisational issues you are incapable of handling. What I had to do for my part is ready. My superheroes and I, we are ready to present the work.

I asked to rest. Or am I not supposed to rest even for a day in order to support the only thing I asked for, which is to present my work?

Anthony said that if there is a need of help regarding urgent expenses you can discuss it with him. There is no need for this arrogance right now. I have had enough of it already from you and your team.

Congrats. You succeeded in being surrounded and very well treated only by those who are afraid of you, who lick your ass because they want something from you, and see you as their boss.

I am not and have never wanted to be one of the above characters, and you can call this separation simply what an artist is. And this is what gives you the space to write to me like this today, which I will take as a compliment.

Georgia

05.06.2017

Mayday 2012

After months of careful plotting, Occupy Wall Street is saying that 'Mayday will never be the same; we're going to the streets again and we don't intend to leave.' The OWS Mayday action joins the traditional International Workers' Day now being reclaimed in the US by over one hundred Occupy organisations across the country and calls for a general strike. In NYC, where Bloomberg News recently compared bankers to elks with the OWS wolves at their heels, OWS warns that the wolves are coming out stronger than ever. At its 30 April press conference OWS will announce its plans to confront the 1% where they plot and play. Speakers will include organisers from OWS, from the locked-out teamsters at Sotheby's, from Occupy CUNY, and from a group of immigrant workers. Spokespersons will explain OWS's call for 'a day without the 99%': No Work No School No Housework No Shopping No Banking – a day of freedom from the corporate marketplace. They will reveal their plans for the day, which include a 'pop-up occupation' of a city park, ninety-nine pickets by OWS, labour and community groups against the 1% and exploitative employers, aiming to disrupt 'business as usual', a march with a guitararmy, a multicultural concert in Union Square with well-known performers, and a Mayday solidarity coalition rally and march from Union Square to Wall Street, of course. They will be marching with thousands of coalition partners from labour and immigrant communities, community organisations, colleges and high schools, where some students will be staging a walkout to join the march, which will be followed after dark by other still-to-be-disclosed OWS actions. 'Anyone who thought Occupy Wall Street was dead will be pleasantly or unpleasantly surprised – depending on which % they occupy – as we begin the beginning of our long march to Social Revolution. No one in the 99% should be afraid to join our peaceful protest on Mayday. Nevertheless, the elks are said to have mustered a large security army', an OWS member remarked, 'Another World is Possible'. Predicting a

new era of more strikes, more disruptions, and more occupations, OWS is saying 'Let Freedom Spring – Zucotti Park is everywhere.'

Let me know if you find others

http://hyperallergic.com/39105/ows-arts-and-culture-group-releases-statement-against-occupy-38

http://hyperallergic.com/38960/occupy-art-things-jumped-the-shark

http://www.nycga.net/groups/arts-and-culture/forum/topic/occupy38-and-artists-space

http://www.huffingtonpost.com/2011/10/24/occupation-soho-artists-space_n_1028745.html

http://www.galleristny.com/2011/10/group-occupies-artists-space-in-soho

https://www.artnews.com/art-in-america/features/ocupy-artists-space-58518

http://www.artreview.com/profiles/blogs/protesters-occupy-artists-space-gallery-1

http://animalnewyork.com/2011/10/artist-leads-failed-occupation-of-art-space

http://www.artfagcity.com/2011/10/24/is-artist-take-artists-space-a-juvenile-critique-of-occupy-wall-street

http://www.thelmagazine.com/TheMeasure/archives/2011/10/24/surprise-artists-occupation-of-non-profit-artist-run-gallery-goes-poorly

http://blogs.villagevoice.com/runninscared/2011/10/occupy_38_what.php

http://www.nytimes.com/2011/10/25/nyregion/occupy-wall-street-splinter-group-occupies-art-gallery.html

http://www.washingtonpost.com/blogs/arts-post/post/take-artists-space-evicted-from-gallery/2011/10/24/gIQAwFbbCM_blog.html

http://blogs.artinfo.com/artintheair/2011/10/24/freakish-occupy-artists-space-action-ends-in-eviction

http://www.artinfo.com/news/story/38975/why-i-support-the-occupy-museums-protesters-and-why-you-should-too

http://www.youtube.com/watch?v=B5ziBkXhwU8

In defence of the General Assembly

The dominant paradigm (as well as the propaganda that this is all we have available as paradigm) is totalitarian capitalism, and by our support of it we ensure that we have only this. Flexible and creative entrepreneurship focuses on the hybrid, consumed, ecstatic celebration of the neoliberal icons of the corporate, staging the performative. It looks like politics, production and function, it looks like object and subject are in some way connected.

Every work of art must develop and carry the reasons of its coming into existence within itself. It can't simply be the naming, the reification of the institution, structure and frame that makes the work visible; neither the thought, nor the calling, nor the signature of the person herself makes it be an artwork. A making could eventually become an artwork if it gains presence beyond the parameters of the institution that made it visible, beyond the structures that seek to value it, and beyond the contexts and parameters that might set it in a particular historical or political frame. Because underneath all these capturings and frames, the way of making remains and sets the character of what this work will eventually be. The work's transitional capacity will give strength to and open up discursive horizons.

The desire that sets the drive and character of making might allow this making to find its way through another rhizome, different from the assumed result. This could eventually set it free from the frame that presumably constituted its coming into being. That separation from the one who made an effort and from the reasons that made it appear will allow the making to be on its own, and make possible the reality that it transmits.

Most of the time the reasons for making something have nothing to do with the representational outcome. The making of a work is for the sake of the effort to actualise a reality that perhaps hasn't been witnessed before, an image that, despite being in front of everyone's eyes, cannot be seen. There is a need to muffle what is too loud and

to obscure what is very much seen. Calibration of powers. Empowerment of voices that are not yet heard. In the centre. A priori in the centre of the reality. The work is an initiator, the sentiment of the making of a reality that is not yet here. Perhaps it has been forgotten, or it is a ghost, a repressed memory, a wish. Oppression (sexual, physical, mental) didn't allow this reality to take shape and form before. She is fighting for this reality to exist. She observes, selects the pigments of what already exists, and in the centre of this observation she sets the parameters to make this reality. It could be called a virtual reality with physical status. This is the effect of the ritual, too: to carry out the affective elements of an actuality that is already a priori a common fact. It exists without needing confirmation.

Practice

If I don't commit to representation what is it that I am visualising as an artist? Am I then a non-visual visual artist?

'Stage of Recovery' is the size of an average small stage. It is 250 centimetres by 250 centimetres in size, and 65 centimetres high. Four large, thick pillows are placed on top, attached to the base, stable, covered with cotton fabric. It can hold the activities of one participant and sometimes myself, and it is only used during the one-to-one sessions. During the sessions the participant is on stage, mostly alone, they are exposing themselves, their condition, on the stage, as they are so used to doing in daily life, with one small difference: here they are working on the condition that made them feel pain. I am around the stage, and I can see what is going on, how the movements are progressing. Sometimes I will ask the participant to repeat a technique, to continue, to take time and to rest. The soft stage is there to remind them that there can be a place that can be soft and easy, a place where, instead of performing a social role, they can release the tension created by that same role that they have constructed for themselves to perform in their daily life. Instead of creating even more difficulty than they have already, the process helps them navigate the ways of releasing the difficulties. The structure is made out of wood, it is installed in a room, it is warm, but sometimes I need a blanket; especially during the breathing techniques, I have noticed that the participant's circulation is altered and that they feel colder than usual.

What in the past started with my need to prepare and to recover from physically and mentally demanding performance pieces, has gradually become a research into the physiological and pathological conditions of the body in the hyper-capitalist era which dooms us to autoimmune illnesses, stress, discomfort, asthma, insomnia, panic attacks, anxiety, fatigue, nausea, food disorders, mania, paranoia, arthritis, depression, addiction, to name a few. Over the years I recognised that some of my own techniques (breathing, movement, voice) could help others to build their own

routine of self-recovery. If in the past this practice was a way to build technique within the medium of performance, now it is a shared practice that is open-ended.

Through 'Dynamis', my contribution to documenta 14, I was able to share my routine within the limitations of an exhibition format, it was blocked in a fixed time of presentation, execution and production and this made me feel constantly defensive. I felt that I was betraying my entire practice for the sake of one artwork and one exhibition. It was difficult to find a way out when I was pressed to contextualise ten years of developing personal techniques into a solid artwork. Those same reasons made me abandon working with a group, there was no time for me to work with the particularities and conditions that each participant was bringing to the work. There was no space to focus, observe and learn from the steps of seeing my personal technique evolve in the bodies of others. There were requirements and limitations in order for the presentation to take place, which didn't allow for anyone to be aware of what their bodies were able to give in the group and in the work, and I was extremely sad that I wasn't able to do what I desired most, which was to help the participants physiologically through my practice.

Some bodies, which means some voices, are under shock and there is a need to form steps for recovery. There is no such thing as recuperation and a healthy, normal state. There is a stage that allows the person to recognise, explore, and learn from their physical condition, illness and pain. How and in which way an organism becomes well is not really definite. In Greek the word *ίαση*, in English '*iasi*', means 'recovery', it is the time it takes for a body to recuperate from illness back to what it was before with the information that has been acquired by that illness. By altering the tuning of the voice, the body starts to vibrate differently, and some of the organs in pain can be touched. Through training I follow and support each participant to tune their voice differently and to realise another interiority of their body. By that tuning they

can become stronger and physically better. The diaphragm is not really an organ but a muscle, it lies between the upper and the lower part of the body and establishes the balance of the interior and exterior of the spine. It sets the balance and it distributes the air, thus it tunes the voice throughout the whole body. Every breath is a tone to the interior and exterior of life. While taking care of the breath the voice starts to sound as it is formed, and the whole world starts to vibrate differently. We can just breathe and we are there, we don't need to make declarations and statements, we can also just be there; so many people forget that breathing in a place is enough. Everything else becomes an extraction from someone else's breath.

The treatment evolves according to what the participant reveals on stage, there is not so much talking but breathing, movement and voice. The techniques came about from 2009 until today while preparing (recovering) for demanding performance works. They evolved mostly through observing people in different places. I started by following and memorising the walks of friends: their movements could tell me how they were, how they felt. If I felt their walking alter, I would ask how they felt, what was going on, and then I would take this information and work on it, day by day. I observed how it translated to my body. I tried observing people in offices, different workers, women in the 1950s presenting cars on rotating platforms, their smiling faces; how they behave is how their bodies are formed through their work, consistently repeating the same routine. I realised that I had to prepare and decompress out of my observation exactly as I hoped their bodies, the workers' bodies, would escape from this physiological manipulation. I find in all of these activities that there is no voice, only executions, bodily executions, there is no time for an articulation of passions: there is no laughing, no crying, all of that happens in a break with self-control. I was observing the builders while real estate was booming in Williamsburg, I recorded the sound of the subway workers,

the hipsters waiting for the train – their postures were similar to the workers during the break – everything was mixed up, collapsing in a huge hyper-capitalist bubble of bodies without voice, only postures, posing, doing everything online, texting, but not speaking. I started to record and mimic their sounds and giggles, and through this I started working on voice techniques and on training my diaphragm as an interior muscle. I never liked to go to the gym, all the techniques happened in bed, on the carpets of different houses, in whatever place I was crashing. None of the techniques are supposed to happen in a particular environment but in one where there is some comfort and time to observe and focus on your body and how you feel.

In 2011, when the Occupy Wall Street movement happened, the voice became a tool and a threat; the public assembly was our power and turned into a criminal act. The oppression and isolation I experienced in the years after brought me to confront the fact that, to know that, the voice is where I needed to focus the most. How we come together on the softness of the stage can recover the pathologies of the social stage we are put into, to play out perfectly made roles without escape, and with no cure, except that of medication and meditation designed, at least, to maintain our efficiency as workers.

For each case I write protocols based on expression, manifestation, then treatment and recovery. Expression is what the participant tells me they feel, the manifestation is what I see happening and what they describe as the cause of their pain and discomfort. The manifestation, which is mostly revealed during the participant's time on the 'Stage of Recovery', will tell us what is happening in general to the participant's body and how they are presently taking care of it. The way they take care of it will tell us how I need to navigate the treatment with them. It is always in the last phase of the sessions that I combine breathing, movement and voice, which becomes the practice of recovery.

The mechanism of paid sick leave is activated only when pathologies, stresses, panic attacks, autoimmune disorders and so on are turned into medically described conditions and are medicated. I try to resist this mechanisation of the body (sick or healthy) and to create a space and time, that they already have, for each participant to find ways to take care of themselves. Through navigating the pathologies that, until this point, seemed insignificant to them, they can recover and continue and prepare for a moment when the body will need to be strong.

How do I write all of this with such conviction? My only imperative as an artist, which is transmitted through my actions, is that no one should lose faith in their own momentum, their power, their personal capabilities. Artists are already aware that no value can be attributed to this momentum, since nature and existence cannot be classified into wage labour, profit and money. I take my experience as an artist, who for many years has worked through performance in demanding bodily and mental states, into a knowledge that is shared, with the hope of helping others to create techniques of self-determination and recovery, 'IASI'. Three art institutions aligned and hosted this practice, allowing me the space and time to expand it into public research.

Each session is between thirty and forty minutes long. It starts with a greeting, a small conversation with the participant. How do they feel, what's been happening recently, do they feel pain and if so where? Then they take off their shoes and they go on stage.

'IASI'

Case

Expression
The shoulders are in pain. Arthritis and difficulty falling asleep. Mind in trouble. No body expression, tasks happen in the mind. So much effort to constantly correspond to the hyperactive surroundings. An exhausting personal environment. Everything is tough: work, communication, physical and mental demands. All seems overwhelming, including at home. The participant is over fifty. There is an urgent need to take care of the nervous system. Every cough is tough. Every touch creates pain. Their body hasn't been touched for a while. How can I touch this body? There is a lot of resistance.

Manifestation
There is strong resistance at the moment of exhale, noise from the throat and a holding back, crying from within, pain on the inner part of the thighs, perhaps the liver tells us that it is tired. When the inhale happens, especially during the 7-1-7 breathing technique, it establishes a long enough time for the participant to 'allow' the air to come in, there is an immediate pattern to exhale with the nose instead of the mouth. We see that there is no strength left for action to happen and there is overthinking. If the participant doesn't inhale enough air then there is not enough air for the hold of the diaphragm to happen, nor for the roll, and no air to exhale. How is it possible to want to give without being able to take in equal proportion, which is to accept an equal proportion of air to go in and out without action being part of breathing, but part of the hold that is the 1, the roll. Breathing is not action, it is to be. The hold is the action.

Expression
Overwhelmed with the kids and responsibility. They tell me, 'There are so many roles I need to perform.' We need to loosen up those roles and abandon them. We need to find

you inside those layers of roles. The immune system could be in danger if the participant is not eating well or sleeping well. We talked about love, the issue of having two roles (father/mother) in the kids' lives. This might create a reaction to them. Let them be, and be proud of them. Do not expect them to be a certain way, but allow them to relax and be loved without imposing a role onto them. We talked about the suffocation of not being able to relax, not being able to enjoy their presence. How can you take care of someone if you are not able to take care of yourself? This phrase sounds like a cliché, I know, but it is repeated here for the participant to realise that their pain comes from trying too hard to perform the role of the parent.

Manifestation
Exhausted and ready to burst into tears when they talk about family. The head is always too low, and the feet are turned out, allowing the inside part of the leg to stretch so much that the nerves, with the intensity of day-to-day life, swell. This heavily compresses the bones.

Treatment
Every time the participant is on stage, the lights should be off. The breathing needs to happen without any demand from me. The breathing needs to happen lying down, with eyes and hands open. They need the time of the session to be a moment for relaxation, comfort and softness. We need to allow comfort and care. To allow the maximum sense of softness. We are doing 5-1-5 and 7-1-7, gradually opening the arms away from the body. The voice will be used in the next session on 5 February 2020.

Recovery
We are not able to move to work with the voice. We try to start the breathing training from 12-1-12 by opening the arms in line with the shoulders while lying down. The

inhale is still less than the exhale, but it seems that the voice is blocked. The participant bursts into tears. They start describing sexual harassment that they experienced when they were young, during music lessons. We devote the session only to breathing with open hands, taking it all in, crying. I am only beside them with the position of a dog ready to attack whoever is there to hurt them. Protecting, securing them until the participant is able to breathe again without crying and feeling suffocated. The voice comes out when there is exhalation. Inhale 5, and 1 is for holding the diaphragm, 5 for exhalation with voice. The participant's voice has, for many years, been presenting a strained tuning, putting pressure on the lungs, increasing stress, making responsibilities appear overwhelming. Slowly they realise that the head, which is always facing down, creates pain in the shoulders. By calming the voice, we will give strength for the head to go back to its place, the shoulders will relax, and the voice will sound clearer. The tuning is two tones lower. The participant starts to feel better.

*

Case

Expression
Fragile body. Violence of the past and fear have been carried for some time. Their mother suffered from loss of voice, a cold father, abusive environment. The body has been used to get out of this abuse, trying hard for someone else's faults and decisions. The body is not anyone else's tool. The body isn't even your tool. It is you, simply you. There is a need to stop making efforts to understand. There are defence mechanisms, excuses, cover-ups in this effort to understand, and we need to realise that we cannot understand. Settle calmly without fear. Be with yourself, tuning with open eyes, you are alive. Relationships are created

with a new voice. 'The body is betraying me,' they told me, crying. We need to work on that. Settle calmly without fear. Own the knowledge gained from all of this pain. Build on taking and giving equally. Breathing in and breathing out equally. Allow yourself to breathe and to hold, and to breathe. Breathing is not an action, it is to be, the holding is the action, your action.

Manifestation
Sore throat, muscles are weak, the upper part of the right shoulder is in constant pain, the left hip, of course, is in pain too. The right knee is in pain, breathing happens mostly with pressure in the chest. Tired, they are not fully rested since breast cancer surgery. Not so many activities. No more dancing. During the second session, I noticed an issue with the balance of the head. The entire head is always tilting forwards, causing pain to the front of the shoulders. There is an entire 'planet' on the back, where the head meets the neck. The shoulders settled there on the spine due to many years of defensive behaviour. The participant stayed there, on this planet, for a long time. They need to leave it behind.

Treatment
The term 'planet' arrives during the session with the participant. We have a discussion about it. What could this word mean in the context of the treatment? 'Planet' is a behavioural adjustment of the body towards its surroundings. It is developed during childhood or in early adulthood, and over the years it becomes a custom for the body. Even when this 'planet' creates a physiological and painful state, the body, in order to continue in its purpose, which is to exist, to live, will eventually normalise the thing that might deform it. In this case, it is clear that the forwards extension of the head creates pain in the right shoulder and in the left hip and is also creating problems with digestion.

Recovery
Breathing technique 7-1-7. The form needs to take place with
gentle pressure on the front part of the shoulders when lying
down. The participant realises that breathing is not action. It
is to be. To be is not work; it is just to be. The unique condi-
tion of the organism is not what it does and how it functions
but that it is, simply existing in its full potential. The stress,
the sore throat, the defensive posture of the body, the voice
that is made childlike, it seems that there is a gap in develop-
ment that needs to be worked through. We need to work on
the planet that is stuck there on the back of the neck. We need
to lower the chin, balance and align the head with the shoul-
ders, soften the hips, soften the knees, and open the chest.
The head needs to sit in its proper place, not tilted forwards
and not tilted backwards. As the diaphragm wakes up, pos-
ture and balance will strengthen. The breathing technique
needs to happen with the 7 inhaling and the 1 to be a roll,
and the 7 exhaling, the 1 to be a roll. When the participant is
doing the roll it is important not to force the head to touch
the knees. During the roll, when the head goes forward, the
tension needs to come from the middle part of the head, and
the shoulders need to be still, open and relaxed. When rising
up there needs to be enough air to exhale, and then they are
back to the first position, with enough air to inhale and roll
and exhale and roll and inhale and roll.

*

Case

Expression
Enclosed shoulders. During our first session I notice that the
right side of their neck is larger, and I ask if thyroid prob-
lems have been an issue. They say that this is something that
they have had since childhood, which comes and goes, but
in our introductory interview they didn't bring it up because

they didn't think it necessary, they only wanted to train their voice. I hear that they don't have enough breath to speak and that their throat doesn't have enough space for air to circulate. Eating is not so easy. I ask if their stomach is sensitive, if sometimes their mouth tastes sour. They tell me they have had stomach problems for years and that they hadn't thought of these as being connected to the thyroid.

Manifestation
The voice sounds weak. The voice is how air circulates inside the body. The body is a speaker, and it says that space is needed in order to evoke sound from within. Even if a person is deaf or mute, air circulation happens and there is sound with the exhale, which is voice. If the vocal chords are sensitive because of the thyroid, the breathing needs to ease. Breathing is not action, it is not something offered to us, we are alive therefore we breathe. Action is the hold, when the diaphragm expands, and that happens in the milliseconds between inhale and exhale. As the air circulates there is a particular vibration that only this unique body makes. Tuning and balancing the inhale and exhale will also allow internal tuning. Practice is a relaxed moment, an inviting moment to train the elasticity of the diaphragm. This activates joy and makes the diaphragm happy and the liver happy. All the organs acquire enough space to be. I do 'IASI' as a way to prepare and recover, and at the same time as an artistic practice. I've done it for quite a few years with groups of people. Now I offer it in a more concentrated way, and this participant can use it to help their thyroid wake up, just as their diaphragm needs to wake up.

Expression
They have always been a bit uneasy with their body. They very recently got fed up with the different roles they have to play; how they 'present themselves' feels somehow fake.

Manifestation
They have never had a severe accident or sickness which would manifest in the form of physical defensiveness, but they are in their mind a lot, which reveals a similar atmosphere. This is a physical state, not a psychological one; it needs to be worked out physically. Psychological doesn't mean emotional. Emotions are sensations that happen physically in the body. They need to work on the physical aspect of expression, which will also help the mind to unblock.

Treatment
Breathing techniques in the morning, especially those that are connected to extended hands in position 12-1-12, and inhale and hold and exhale and hold. The diaphragm feels the misery of the thyroid. The body has been in passive mode for many years. We need to wake up the participant. To take action, to speak out. The voice is weak, I can barely hear them.

Recovery
They need to allow time for themselves in order to realise that they need to take care of themselves.

*

Case

Expression
They are worried about their back pain and difficulty sleeping. There is pressure to achieve success. There is anxiety about how to make that possible. Anxiety about the future, finding the right job. There is constant pressure to fit into the category of the best student, the best employee, but at the same time they feel miserable because they don't do what they really want.

Manifestation

A sense of comfort comes through self-punishment; with tension in the stomach and through the repetitive action of either refusing to eat or eating excessively and then vomiting. They never describe the food disorder to me as an action. When we have the conversation about what brought them to 'IASI', I notice I am trying to imagine how this action might be, and how it feels for them to keep this action and its pleasure a secret. The left side is squeezed in, there is damage there that causes pain to the lower back. I advise the participant to go for an X-ray. There is dysmorphia in the posture. Returning from the X-ray, they tell me that they have cracked ribs and the doctor prescribed them painkillers. I advise them to practise. They need to take care of their breathing in order to create space from within. There is refusal to accept that the body is stronger than the mind. The mind will not survive you. The mind is holding them back from accepting that their body will always try to survive, more than the mind is able even to imagine.

Treatment

The voice comes out with force, but only from the throat. The throat is dry. Treatment slowly takes place. Becoming aware of their posture through the hold in each of the exercises, they maintain ever more pressure to the diaphragm and allow space to be created from within. They start to feel pain. They start to feel the pain of the cracked ribs. Dysmorphia comes from the repetitive act of vomiting. The sensation of pressure in vomiting and the pleasure that it creates is addictive, because it is an anxiety release. Hopefully through the treatment they will allow the air, the expansion of the diaphragm, to soothe the organs which are now burning. But only if the participant allows the body to be with its complete capacity, firstly full of air. Only then will the body get motivated to want to exist, to need to survive, therefore to ask for nutrition and to incorporate eating

as a daily, pleasurable activity. The treatment is split into two parts:

1. Tricking the mind into physical activities that build no judgement: very slow progression from easy exercises that strengthen the diaphragm to more physical breathing techniques such as 6-3-6 (6 is standing, inhaling, 3 is falling back with a longer expansion of the diaphragm, 6 is coming back to standing and exhaling) or 7-1-7 (kneeling on the stage, spine straight, and using the voice in the exhale).

2. Spending the entire session resting, calming down and taking the time to do nothing. Setting up an environment of rest for the participant with unconditional time and space for self-love.

Recovery
The participant says they are busy and they cannot complete the treatment.

*

Case

Expression
Chronic back pain resulted in a surgery to the lower spine. In the first session, it was very difficult for the participant to climb onto the stage and lie down.

Manifestation
Their knees are tight. A very tall, elegant body has gracefully covered their pain for many years. I notice how clothing surrounds their body like camouflage. They make sure discomfort remains unrevealed. There are more signs: big, frozen smile, controlled posture, chin tucked in, slow walking, everything becomes a ritual to hide pain. The way fabric touches them is their way to recovery. I concentrate on that

idea and build a prayer. There is fatigue and some kind of shyness which comes from a period of self-destruction. All of this has the form of self-punishment. There is a heavy past, violence. Fragile beauty turned into harmed beauty.

Expression
From the third session onwards there was an improvement when we discussed the stiff knees and the curve of the back during breathing. All the time there is basically lordosis, which becomes more clear during the inhale. Flexibility doesn't come naturally to this body; it seems it has gone through much daily exercise, such as yoga with a dominant teacher, to violently prove (to whom – to the teacher?) the opposite. We need to unlearn the stiff and dominant, military way of practising. We need to find ways to soothe the body through breathing, through very gentle micro-movements. We need to slowly let go of this idea that dominating and controlling the body will immediately result in the abandoning of ego, grief, habits, sorrow, negative thinking and loneliness.

Treatment
Very gentle bending of the knees towards the chest, while the diaphragm is held during its expansion. One after the other, with my help, they raise their legs during hold. The right side seems to be more sensitive. This tension in the lower part of the right hip is an indication that this was the side where the surgery took place. The session happens at a slow pace and all the exercises occur with eyes open. When the inhale takes place I wait for the hold of the diaphragm to happen and in parallel I help the participant to bring their knee towards the chest. Action happens when hold happens, never when there is inhalation and exhalation. It is important to listen and to go along with the participant's breathing tempo. Raising and lowering of the knee must happen slowly, with a circular motion. I bring the knee towards the chest and slowly bring it back and lie it down on the soft surface. The hip clicks. I

move to the side, I help the participant to lie on their left side and rest. After a few seconds, we return to the initial position and do the same motion with the left leg. The hip here seems softer. For this session the breathing is 5-1-5 and gradually changes to 7-1-7 and 12-1-12. With 5-1-5 the arms are close to the body, it is the position that supports the kidneys and digestive organs. As we create more space the tempo is faster, but the 5-1-5 remains the complete breath, the entirety of the air. The breathing technique called 5-1-5 includes the inhale, the hold and the exhale. We have been educated that the smaller the number the faster it will be, but here we try to reverse this idea. There is neither faster nor slower, and there is no numerical comparison between the 5 as small and the 12 as large. What we try to do is to create expansion of the diaphragm in its whole potential by measuring 5 as the whole, just as in music we have 8. A 'call' is the way we establish the breathing's tempo, it is an invitation for air to come in. If we are able to call, to be aware, for the whole 5, then inside 5 we can fit 7 and 12. Meaning that in the exhale and the inhale we will have equal giving and taking, gently realising that the smaller the number the more space we build. If we are not able to realise the 5, then we cannot fit 12 inside it. The 1 is the hold of the diaphragm. Sometimes this rhythm of the hold might take longer than 1, but this is not an issue. I follow the participant. This training happens only during the last session of the week in order to give time for rest at the weekend. The participant takes sessions three times per week.

Recovery

There is a recovery. Slowly, from the third session onwards, the pain becomes less strong. The participant feels very happy and that gives both of us lots of energy to complete the sessions. It is clear that the damage that has occurred needs patience and practise to recover from. They need to find a way to set a daily morning routine, a personal time to

train, to recover and to take care of their spine's flexibility, which will carry them for the years to come.

*

Case

Expression
The participant wanted to work on their voice. They felt self-aware, shy and irritated about it.

Manifestation
Small body, scoliosis and compressed spine, arms turned in, palms inflexible, chest larger proportionally than the head, and the legs and arms are weak. A lot of pain inside and outside. There are signals that their pain comes from overthinking the pain they have experienced since childhood. They have experienced abuse and violence because of how they look, they arrive with overconfidence towards me. They tell me about how they need to change their voice, I say I would like to help, and ask if their back is in pain and they say it is always in pain but they are used to it.

Treatment
To bring the air and call the breathing is something that we need to feel we deserve. If the participant uses overconfidence to defend their being, then breathing is part of this defence and it comes in with too much opening of the chest, which pushes the front forwards, eliminating the back. I tell them that to be is not something that they need to defend, because already their organism, in its core, as nature, will try to survive them no matter what, no matter if they think of it or not. We need to call for air not as a mechanical function but as a hint to appreciate that this soma that we are is able to maintain us, sustain us, live us without our needing to think of it and turning it into a tool.

After the second session, I design a step that allows the participant to reach the stage and then fold to the side, to fall slowly on their right side and slowly stretch their body on the stage. This step also helps in the exercise of the voice and breathing, where I push my back against the back of the participant and allow both of our spines to adjust with one another and train together. With this method, 5-1-5 and 7-1-7 breathing techniques allow me to listen to the spine and how it vibrates with their voice, to understand its flexibility sensorially and to build trust with the participant, making it possible for both of us to describe better what we feel is going on during the sessions. The step helps the participant to have balance and press evenly through their feet, so I can raise their hands and help them understand their entire presence, which can no longer be defined by their height. We are starting to talk about what is unique. I am trying to say that *how* every person is, is a unique case. I point to the trees outside and describe how even though we might think that the word 'tree' could define all the trees in this part of the park, if we pay attention we will start to notice their differences; they have different branches, the shape of their leaves is completely different. If we pay even more attention we will notice that even those trees that look the same, that come from the same species, are very much unique, they exist uniquely in comparison to the others and are also different in and of themselves. I try to explain that this is not only about how we understand ourselves physically, like a flat image; if this understanding comes through the judgements of others or through the mirror stage, it splits how we feel from who we are. The 'other' is really ourselves, we need to think of the body as the only chance to realise, through sensations, pain and passions, that the other is in us. This notion could allow the possibility to search for who we are from within as others. Outside-is-inside means that we shift the way we work on pathological sensations. 'Symptom' for 'IASI' is not a *lack of*, we observe 'symptom' as a set of skills, of what the body is

capable of. 'Symptom' *as plus* enables a step into revelations, appreciations, admirations, and a realisation of life, of who we are, of our nature, which is not total, not one, not straight.

Recovery
In one of the sessions they tell me that they feel calmer when they do the breathing techniques in the morning. They face the world with good air already inside them, then the world opens up to them. They are able to breathe from the nose and exhale from the mouth and not feel suffocated any longer by only using their mouth to breathe. Their acting teacher told them that she noticed their voice is slightly clearer. They wait, they hold the diaphragm as we did during the sessions, they inhale to call for the air and then they exhale. The diaphragm is somehow more present and touches their spine, and they are in the world with relaxed shoulders, which they say is an improvement.

Spiritual anarchism

We are trying to make a space in which desire, exchange, libidinal economies, can be possible without centralised organisation. A few of us are queer, some women and some men; we try to maintain the space with few means. There was a time we considered stopping paying rent and demanding to remain inside. But who would be our representative and hold and maintain the negotiations following this decision? None of us wanted to take on the political agenda this responsibility might bring, so we dropped the idea. We didn't want to buy the house, we didn't want to own anything in order to be together. We wanted to gain time to feel ourselves in the common, everyday struggle.

At ten in the evening we discussed creating ethics, daily routines for going beyond morals and doing ethics. Forms of participating in the house, at school, at work, on the streets, in meetings to become hyper-sensitive, to recognise relationships, to recognise that they are formed in moments of emotional limbo; to cultivate and commit to extensions of the self. The incomplete self links with other incomplete selves to perceive the world. Not based on universal truths, neither from a predefined social agenda nor a personal one, the ethics of these transformative moments are made when the Nietzschean 'God is dead' shifts to 'the gods are constantly created'. Ethics are sets of negotiable temporalities.

Anarchism is read through its political definition as αναρχία ('an-archia'), 'without power', but it can also be translated as αναρχή ('an-arche'), 'without beginning'. It seems almost the same but if we think of anarchy through its temporal definition, 'without beginning', we can understand why anarchist political organisations cannot fulfil their political programmes. This is exactly what makes anarchism the most relevant and revolutionary ideology of our time. Anarchism is a time-process of political subjectivation and formation. The political subject is made through a constant emotional and political limbo, made *in* anarchy, meaning that it cannot

fulfil any pre-existing agenda but it does fulfil ethics: the ethics of freedom to come.

When this time in anarchy is enclosed by an agenda it becomes communism (for the good of the group), neoliberalism (for the good of the individual) or capitalism (for the good of the market). Anarchy is to gain time without beginning, without *arche*. Life is to become materialised in multiple ways but never to become enclosed, never to be aware of its beginning. Life without the awareness of its beginning is as constant as movement.

NYC General Assemblies

NYC General Assemblies are an open, participatory and horizontally organised process through which we are building the capacity to constitute ourselves in public as autonomous collective forces within and against representative politics, cultural death and the crisis of our times.

NYC General Assemblies are a gathering of individuals, coming from various political, economic, ideological and cultural backgrounds. With our voices and our presence, we share our problems, fears, ideas and dreams. The General Assembly is not a group. General Assemblies break the idea of the political group by bringing together a variety of ideological patterns, old political procedures, testing them in public, exposing them, acting upon them and transforming them. There is no leadership, no representation and no authority. We become political beings through our participation in the commons. The process of the General Assembly is already a fundamental action. To be able to make decisions together for a resolution, to participate in an action, to hold a gathering and political conversation in the most policed city in the world, is itself a political statement. NYC General Assemblies are actions that open space rather than producing polarisations. They create environments for everyone to have a unique and important role.

The people of the General Assemblies are everyone. It is you who sees the limits of the politics of alienation, the cruelty of the economic regimes, cultural hypnosis and the standardisation of every form of life for the benefits of the 1%.

Who Represents You Replaces You.

We are the 99%

On 17 September we occupied Wall Street.

The Wall Street occupation doesn't claim any responsibility or control for the spontaneous initiatives, practices and direct actions taken by the people in the streets of New York.

The Wall Street occupation is not a metaphor. It is the coupling of politics and life that wasn't even imaginable a few months ago.

The NYC General Assembly is not a central political formation. It moves the bodies. Sometimes gatherings split to exist in smaller units in the spaces of the metropolis, and sometimes they gather together again when it is needed. Who is able to predict what those bodies will want and need, and when? There can't be any leader or leading idea to this movement, but only forces, forces of sentiment.

Occupy Oakland support fund

We need as many people as possible to come out in support of this fund. The NYC Occupy Wall Street accounting working group is making proposals which will essentially use up all the remaining money that OWS has. So, this is basically a last chance to help fund the movement as a national movement rather than a closed-off NYC group which buys Metro cards and blows through $500,000 in three months. Occupy Oakland's accounts are down to roughly $3,000 now as far as I know. NYC is down to around $300,000 and the accounting working group is proposing what to do with $126,000 of that, while also claiming that approximately $100,000 will need to be reserved for taxes. The basic proposal presented on Tuesday at the OWS General Assembly which got shelved until Thursday was to distribute $30,000 of funding among the West Coast cities involved with the West Coast port shutdown. This was to reimburse the movement and to keep it funded for continued actions including the upcoming blockade in solidarity with the International Longshore and Warehouse Union. The proposal met resistance from the accounting working group for process-related issues which they framed as ethical blocks. We are returning with a reframed proposal from Occupy Oakland which is roughly stated below, and will include a complete budget (roughly $18,000) for the shutdown (and receipts if we can get them in time) and the proposed budget for the ILWU action (roughly $12,000). We will send an updated proposal that was submitted to the NYC GA facilitation group and will likely be slightly modified as we continue to work on it.

Message for Thankstaking

The autonomous occupation of 90 Fifth Avenue, which began its second phase on Wednesday 23 November, continues. Today we celebrate Thankstaking, in solidarity with the general strike in Portugal, the ongoing revolutionary movement in Egypt, and the comrades worldwide rejecting all forms of authority and manipulation.

An occupation cannot be voted away – it continues as long as the occupiers decide to stay, to show support, and to keep coming. As we said on 18 November, 'private spaces must be liberated'. We believe this as much now as we did then. So, this private space remains liberated.

Walking by the location offered by the New School administration, 2 West 13th Street, we saw the results of the most superficial expression of participatory democracy: a list of rules and an empty space waiting for its subjects.

It is clear that this occupation was never about, or for, the students; it was about destroying student-identity politics. This occupation's affiliation and solidarity with the All-NYC Student General Assembly often served to confuse its participants, as well as everyone else. A student can only be talked to as a student, which is exactly what we saw from the administration. What began as patronising tacit support led to a condescending theatre of negotiation. We do not accept the representations (of us) that have been used to oppress us. We are not students, workers, activists, or anything else. We are angry, and we want it all.

What the collaborationists among us have failed to understand, and what they have obscured in their communications with comrades and the wider public, is that we wouldn't have needed to form a movement if we wanted to maintain a culture of compromise in the university, in the workplace, in the home, in the street – this is what we were already doing. If some want to continue, they can feel free. Anyone looking to experiment with other options is welcome to join us in this occupation of 90 Fifth Avenue, and in all the other occupations we expect to see soon.

We have decided to take what we want, we realise that what we want is already ours, and we recognise that all those who try to inhibit these movements place themselves on the opposite side of the barricades.

24.11.2011

Outreach text

We need to change:

From
One senses at this juncture, in the midst of the revolutionary struggles across North Africa, the Middle East, and now the Mediterranean, that there is renewed understanding of what politics or democracy can look like.

To
One senses at this juncture, in the midst of the revolutionary struggles across North Africa, the Middle East, and now the Mediterranean, that there is renewed understanding of what non-representative politics can look like.

27.07.2011

Chóros

The philosopher Cornelius Castoriadis uses the word 'Chaos' as the beginning or the place of potentiality, and 'Polis' as the space where the cracks and the openings of the social imagination take place. The political is the historical, that is, social points of coming together and sharing. The Polis is where a gathering happens for a second and then immediately breaks apart. It is the point during a heavily policed march when the de-arrest happens, when a friend is rescued from the police, the realisation that you have someone to run with on the streets, and the way in which you forget your own survival.

Our comrades in Egypt said that we show them the streets and they show us the squares. It is true. The assemblies in the squares are modules for the destruction of representative politics. They are for the people to gather and let the Chaos fold and unfold, without prediction. To obscure prediction is the worst threat to power. Now the Polis demands to live and deterritorialise space. Occupation is not only to take back, but to open spaces, for everyone and everything. This is what the phrase 'we are everywhere' means.

A few minutes ago I had a conversation with some comrades here in Athens about what we call *Chóros* (Space). The anarchist milieu in Athens does not say 'the anarchists did that' but rather 'the *Chóros* did that' ('the Space did that'). In a way this phrasing describes that it is not the people but the transformation of the *Chóros* (Space) that is always in question. The Space changes, not those who constitute it. We alter the *Chóros* through our shared experiences: the way we speak to each other, the terms we choose to use in our conversations, the passing by, the places we choose to meet and have discussions, fall in love, and fuck. This is *Chorós* (Dance) too, with the steps detailing the movement and the manner in which people come together, produce interactions and create Space. It is how in ancient drama the *Chorós* (Chorus) distributes the Space by singing and dancing; it is the presentation of the Polis on stage while the theatre is enacted. That's what I think Castoriadis means, then, when he speaks

about self-limitation. When being inside a Space there is always an idea of the self that prevents us from imagining ourselves creating Space; *making* politics is a rejection of, and in opposition to, simply being inside the Space and *doing* politics. To make politics is to first and foremost distribute Space and demand Life.

Yesterday, Athens marked 6 December, where three years ago Alexis, a young boy, was murdered by a police bullet. Many kids from different neighbourhoods in the city met on the streets to share their memory and to fight the police. There were two marches, one for high school students at noon and another for the workers and political groups at six in the evening. I set an appointment for the evening march with one of my best friends from high school, whom I haven't seen since December 2008 when Alexis was assassinated and the insurrection was dispersed all over the country. The shared sentiment was tense, peculiar, a mixture of sadness and passion. The youngest of the participants were full of excitement, anxious to put forward some kind of action, any kind of action and to make public that this is their moment. A moment for them to actualise with their presence a new mark in history and a social memory, a contemporary celebration coming from the struggles of the youth. They met down on the streets to confront the police and they continued until late in the evening. Many older anarchists spoke against them: 'Who are those kids, we hardly ever see them at the assembly, they don't know how to protest, why do they wear masks so early, why do they move like that in this part of the city and put the march in danger ... blah blah blah.'

I would never think that these youths are not part of the *Chóros* (Space), though many said so. For some older anarchists, *Chóros* (Space) is the getting inside of a particular space, by attending the assembly, going to the march, watching how others interact and following certain traditions. But for other anarchists, *Chóros* (Space) is better understood simultaneously as a passage and as a commitment. Through

our engagement and social participation, the *Chóros* (Space) continuously transforms. Creating territories and being in motion is harder than making strategies and executing them. To open *Chóros* (Space) is to be able to constantly change.

We refuse to make any orders for others to follow, and we continue to move in the march with the calls of the young comrades, running to and placing ourselves in the territories they have made.

Yours, G

Occupy

I think we are very much at the beginning. There can't be any action until there is a body of people (thousands) to support action and make decisions together. There can't be a body of people if we don't call on everyone to participate. I think the starting point is to start calling on everyone to be part of the General Assembly. Let's see what will happen with that first. We don't aim for representatives of groups, but individuals. We want everyone's presence.

I am not fond of having any conversation about any, and I am saying ANY, action over a Google Doc. Also, I don't understand when and who determined the time limit of anything. I don't think that what we are doing is to create expectations. To create a media buzz takes nothing, to post a text on the internet and advertise an occupation is nothing, to make people feel the urgency of something in a way that will only lead them straight to the police is insanity to me. When I am talking about numbers, I mean to create environments and possibilities for everyone to participate. If the purpose of this circle is to organise a specific action, I am not part of it. Put it on the record.

04.08.2011

What is Occupy?

What is Occupy? Occupy is a verb. Some people are thinking of Occupy as some kind of 'organisation' with demands. I'm opposed to that idea. Some people are talking as 'members' of Occupy, I'm opposed to that. And some people are talking as if they're working for Occupy, I'm opposed to this as well.

No demands. The connection is Egypt. And Spain. And Athens. And then everywhere. But they're not the same thing. The connections are like echoes, a shared tempo of ideas and sentiments. It's not the form that connects them, but issues, issues of living – the economic crisis, which is capitalism in crisis – and the disbelief in representative politics.

In the history of social uprisings, you have a figure, or figures, who create a centre of magnitude, and they bring people together, and then come the social uprisings. But this is the past and we learned what kind of figures these uprisings bring: they bring authority. What happened with Occupy, which is new, is that it underlined, very much from the beginning, that the leader is each one of the participants of the movement. Each person has power, each person is the movement. And that's it.

For New York, the General Assembly is an action and it is a threat. To take that step – to assemble in public, neither to consume, nor to work, nor to entertain yourself, but to be critical, to meet with others and to bring issues (political, social, everyday issues) into the public sphere and to talk about them openly without fear – is a threat.

The General Assembly awakens this thing: first of all, that there are no individual issues, the individual becomes social the moment they express something in public and receive responses from another. It is the presence of the body, the expression of the voice, the thinking, and the listening, the conversation, and – of course – the organising (self-organising and in groups). The creation of relationships, the creation of affinities, the creation of mutual aid. Those physical and present relationships create the possibility of actualising things together, by creating them here and now.

I was and I am still against any idea of facilitation. The assembly is a module. What I mean by 'module' is that the assembly is a spontaneous gathering of people, in public, always under the condition of transformation. Such transformation can take any shape: it can become a march, a kitchen, a riot, etc. All of these are welcomed because they bring something which cannot be predicted by anyone in the assembly and which can immediately actualise the sentiment of its participants. The assembly is not a decision-making body, it is a body. The moment you have facilitation there is the assumption of an end point or a cause, and that makes everyone expectant and does not allow the unpredictable to occur. Of course, if you don't participate, and you come as a tourist, as a spectator, you will need a committee to tell you what to do, and the assembly becomes just spectacle, trapped in endless bureaucratic procedures. And if you are not assembling and you are not physically present, there's no such thing as an assembly.

For me, the most important thing that happened with Occupy was, in moments, the feeling of property and individualism breaking. This feeling, which expanded, belongs to anyone – the People's Kitchen, the People's Library. The book is not of the librarian, it's not of the library group, it's everyone's. Everyone can take this book and read it – read it and perhaps return it. These were the moments that educated us, therefore we will be able to see them happening and make them happen again.

You would go to the park, and it would be this place where you could just hang out and start talking to anyone. By your presence you were creating the environment where you felt apart from this city's craziness. A place where you could feel your dreams of how you want a society to be. Then you would leave and meet people elsewhere, and the whole city would be different, and in that moment you would feel alive.

Letter from the ocean

Dear Mother,
I listen to you carefully, all your concerns and fears

And I repeat to you, if what I do is false
To recognise the possibility in the beauty of light, is the
 source of joy
To search for light is where the beauty is, when our pain is
 recognised

The water is sweet
The colours are brighter
My body is awakened
My body is my weapon

Life can be found in peace
Peace is complex

I am in empathy
I am in empathy
I feel
I follow sensation
I follow sensation

The ground is thick
The smell of the ground
Extended branches of unknown plants
Life can be found without asking
Silence is for the privileged
Scream is for the privileged, too

What if I don't seek
What if I don't stare
What if I don't beg
What if I don't want
What if I don't need

What is left for us to talk of
But love

Death

How to address violence, how to address specifically the racist violence against identities that the state has decided are targets. It is not isolated. Who would I be *not* to take responsibility for this death. I need to be attentive, or there won't be any affective responsibility. To care, participate and feel without pretending this violence is a topic. This is what I meant when I wrote that the trophy terms of the left's speech become neoliberal. 'Police brutality': years ago I wrote that it is becoming a topic and that's dangerous because we don't find our own words. It cannot be treated as topical in an NGO meeting. White privilege is looking upon pain as an issue to resolve with institutions and institutionalised language, and not as our reality. White privilege is making our reality into a topic, and not feeling it. I do not mean identifying. White privilege is that people's deaths become topical, which means abandoning the weight of death. How do I take responsibility, without taking responsibility as a given right. In order to have a right, a status is bestowed by an institution or state, in order to be a citizen with rights. What does it mean to pretend to be a citizen like this? This status of responsibility must be taken by myself, not because it is my right. This responsibility should not come through the process of institutionalisation. It must be taken affectively in the body, because people are dying without reason. Why is it so difficult to speak about pain without the pretext of institutions? Either we have the communal, or we have institutions. Everything becomes institutional or corporate, and if there is no such thing as a common spirit or feeling, then we are done. If the only way to feel something is through what is right, then we have total numbing, complete brutality, objecthood, fascism. One totality. One. Avoidance of pain. I cannot feel as one. I cannot feel if it is not for another. Do you think you can feel through what you have, through what you own? You feel through the other.

*

Now, in the pandemic, we march in the street because we want to have the right to shop and to travel. We are in the street to complain about no shops and no bars. Today I saw people queueing, waiting for the shops to open. Waiting for shops to open so we can feel good and normalise the pain. Working hard to mute the pain, not working through the pain. So there is no information shared. We must open a dialogue with pain, not avoid it, because the pain is information. Stop numbing the pain. We don't call this white supremacy, but it is. Globally we are going into this perfection of one. We must work through not falling into this insanity. Be attentive. I need to go there and I need to feel it. There cannot be delegation now. There cannot be a substitute for the pain, the pain is a request for attention. This is Simone Weil. And it is the terrain of anarchism. There is no struggle without the recognition of pain. Delegation, evasion and denial resemble addiction (to avoidance). Consumer addiction is now what brings us together; an addiction to amnesia, supplements, distraction, an addiction to not taking responsibility. Accept we are part of the violence that is being created, and suffer from it. How can this responsibility turn into a set of topics for liberals to safely discuss in institutions? How can this insanity have happened? The topics accumulate in order that the violence not be addressed. Instead, we want to fix ourselves and not be part of the violence. Being a nice person does not stop you being responsible. We have to let pain and violence affect us. In delegating, there is perpetuating. Going there and feeling it gives another sense of being in the world. One that is normally found in spiritual texts. It is crucial to understand this book as being part of the violence, and affected by this violence. How can we begin to recover if we do not accept that we are responsible for this violence? Instead we delegate and accumulate to shore up our status, this is the heritage of white supremacy. For Weil, change in someone means change in the world. It's not about finding out who did the violence, but knowing that it was us.

Amphitheatre

Action is a vital principle of drama. The word drama comes from the verb δρώ ('dro'), which in Greek means 'to do', 'to act'. You may have the right words, but in order to build action you need more than words. When action is formed, noise is produced, and immediately there is something to be listened to. The word is not something to hold onto. It is for hearing. The world, life itself, is a pigment of vibrations, in relation to and constantly composed with that which was before, and will be after. Memory is revealed to us through a constant, audible, vibrant mass, in the listening to of nowness. The noise of an aeroplane thrusting through the clouds, the beating of a heart, the crisscrossing of cars, the sound of waves crashing against a pile of rocks, the barking of a dog, the winds, the water, the storms: all manifest action, human and nonhuman. The world, this mass of energy, this constant hearing, is also a reminder that we are part of a larger composition of others' existence, actions and decisions.

Exposed among the noises of ourselves and of others, we declare co-existence to each other. It is impossible for action to happen only by the character's image or form; there is a need for context, location, what this character is capable of, their content, the motivations behind the action and its length. Music as an autonomous production is a relatively recent invention, until the eighteenth century it was effectively submerged in a greater totality. Similar to the rest of the arts, music, like theatre and dance, was interconnected, and part of a large scheme of participation within the social, communal, everyday calendar. The arts were not perceived as an individual expression, they were for the purpose of marking togetherness through ceremonies and rituals, transmitting, communicating and sharing knowledge. Stories and information were shared through movement and oral narration at the moment of their praxis, at the moment of action. Occasionally within the collective, agents appeared who had the ability to embody and circulate knowledge. They had the capacity to both produce and reproduce. They

were responsible for embodying the double power of means without ends, and beginnings without means. This double power slowly became the alchemic taboo, which remains the omnipresent compromise we now call class.

Now the world is here to provide us thirst and lack of meaning. Information is eaten and digested at full speed; technologies of the body, new numerical, algorithmic and statistical understandings of the natural and human existence transform our perception of time, space and action. Background music acts as an antidepressant and provides a sense of relaxation and safety. The constant presence of soundtracks during daily activities turns noise into a demand that soundproofs the individual. Wherever there is music there is money. Self-policing is inevitable: our own actions (sounds) become unbearable in this endless criminalisation of noise. Every voice, emotion and word that doesn't sound right is excluded as disturbance. Every action is perceived as a sound that needs to be composed. Actions turn into commodities that should either be exchanged or suppressed. The violence of refined emotions producing perfect actions means that these actions are always coming from someone else, are seen by someone else, and in order to be mine they are sold to me in perfection. Ready-made actions circulate, while being constantly refined and recomposed. When we act it feels like we are in a re-enactment. We execute actions as feedback of exchange from a general all-to-all circuit. Simone de Beauvoir says, 'Since it is unjustifiable from without, to declare from without that it is unjustifiable is not to condemn it. And the truth is that outside of existence there is nobody. Man exists. For him it is not a question of wondering whether his presence in the world is useful, whether life is worth the trouble of being lived. These questions make no sense. It is a matter of knowing whether he wants to live and under what conditions.' Fear and urgency to make our existence possible, as well as doubts about our worth, make us abandon any kind of ethics. This urgency to survive is so well composed that

it surpasses the comfort of belonging, the class struggle and the grounding imperative of pleasure. We are here, free, only via the free market. We are here to establish the world, which is the work of our own making, re-enacted. 'If God is dead, everything is permitted' is the motto of our generation of absolute capitalism, whether private or state. Beauvoir says, 'In order for the universe of revolutionary values to arise, a subjective movement must create them in revolt and hope. And this movement appears so essential to Marxists that if an intellectual or a bourgeois also claims to want revolution, they distrust him. They think that it is only from the outside, by abstract recognition, that the bourgeois intellectual can adhere to these values which he himself has not set up.' Now, on the contrary, conflicts between classes and over living conditions are muted by the imperative comfort of freedom that the free market provides. No one – as we are all free in the face of free market – could identify as being completely and 'purely' oppressed enough to act. Both Marxists and neoliberal capitalists, both left- and right-wing ideologists agree on that; they agree on the existence of an outside force that will be responsible for the course of history, that we will need in order to act. Of course there is no such force; the only force that moves everything is capitalism, obviously. We live in the end of ideologies and this is why, as with any of our own actions, political action seems out of sync.

Financial capitalism gives many choices of identity and many lifestyle excuses: the precarious, the neoliberal corporate freak, the elitist politician, the political artist, the state-funded researcher; the list is endless and everyone can select from it. The struggle is for survival and the fight has turned to money-making for the sake of money-making as a new creative field. In order for life to sound right, it needs to be coded and turned into sound. But sound cannot simply be. Music, either written or programmed, is an execution of composition, and composition suggests authorship. Notation is representation. Scores put life in order and set rules of

production to reproduction's flow. The search for harmony, the commitment to precision in execution, becomes itself a form of measurement and a representation in simulacra of continuous order in exchange.

Music remained the same in the village, the market-place, and the lordly courts throughout the Middle Ages. In the fourteenth century everything changed. Church music became secularised and autonomous from the chant; it started to use an increasing number of instruments and incorporated popular melodies. Within three centuries the courts had banished the *jongleur* (the juggler), the voice of the people, and no longer listened to anything but scored music performed by salaried musicians (made within the territories of the palace and the church). Power had taken hold, becoming hierarchical and distant. It is striking how the instrumentalisation of noise was in sync with the pro-gramme of 'witch hunts' that took place in central Europe and the Americas for more than two centuries. Traditions and myths, closely related to the admiration of nature and the feminine cycles of life's transformation (birth–death–rebirth), shared within a communal calendar of people, were burnt, vanished and forgotten. Their noises, the dancing and the healing, were present at the moment of action. The programme of applying executional coherence onto senso-rial actions was a long and horrific process. The Bible was printed in the fifteenth century. For Puritans in England and in the Americas, the Bible literally became the ruling script to be executed word by word in daily life. The Bible became the scenario of the everyday, similar to the score that was executed by the salaried musicians of the fourteenth century who trained endlessly to follow permitted codes within the ruling spaces of the palace and the church. The palace, the church, the court, as well as the theatre, imply an inscribed score of actions, with durations and behaviours activated by the ruling figures (the king, the priest, the judge, the actor) for everyone else.

The continuous cultivation of social roles and their position within the action of social life – obeying the norm to power is submission to these roles – confirms the absolute moral dichotomy of the natural. The binary understanding of man and nature, mind and body, good and bad, inside and outside, inclusion and exclusion, was a way for 'the different' to submit to the social codes of a society that was acting according to the script of a religion directly obeying the philosophical Puritanism of the time. Even in the analysis of authority of that time and for the years to come, political and philosophical alternatives still accept the oppositional and Cartesian perception as inevitable. Imposed power is the norm. For the radical left as well, capitalism and the state are analysed and criticised with this imperative binary of ruler and ruled, of central committee and people, turning any action into either reformist or reactionary criticism. The call for freedom of expression that now seems to be the motto of the full spectrum of politics, sets aside the very basis of how this freedom is constituted, how it is articulated and in whose favour. If the call for freedom is not able to destabilise power, then what is the reason to express it? Is this free expression a testament to power? Will freedom of expression always be permitted within the very core of capitalist ontology? Capitalist ontology is expression as creation of property, fragmentation, appropriation and extraction, as confirmation of the norm, which is duality: it is the end and the beginning, the origin and the unit. Isn't it so that the majority of art since the beginning of the colonial programme, within the territories of the colonies and through the expansion of colonialism as a notion, affirms the colonial premise to be ruled by freedom without being free? The very call for freedom will be a subtitle to this colonial premise of freedom and a property of it.

23 January 2016: 'I could stand in the middle of Fifth Avenue and shoot somebody and I wouldn't lose voters.' This statement was made by Donald Trump in Iowa during his

presidential campaign. This is the level of certainty about the loyalty of his supporters. The apparatus of the amphitheatre was invented way before the ghettos, the prisons and the clinics. It was invented in the sixth century BC in Athens, Greece, in parallel to the creation of democracy, which marked the establishment of a ruling group, the aristocracy, and what we call people, δῆμος ('demos'), turned into the state, κράτος ('kratos'). The people are the aristocracy who made democracy; democracy is the state. Both democracy and its actors manifest through the acoustics of the amphitheatre. The first one ever built was located at Epidaurus in Argolis in the Peloponnese, and was formed of the buildings of the sanctuary of Asclepius, one of the most important healing centres during ancient times. Asclepius possessed healing powers that he received from his father, Apollo. His mother was the human woman Coronida, making him a bridge between the mortal and the immortal worlds. Asclepius was a trans-human, so to speak. In the height of its success the area of Epidaurus was a site of reference for people all over Greece, corresponding to other major healing centres and temples in the Middle East and the Mediterranean. The area provided springs, baths and athletic venues, as well as shops where idols were made, the temple of Apollo, the houses of the priests and of course the amphitheatre. Bathing was one of the core treatments of the sanctuary and healing processes included singing, offerings and the extraction of body fluids: sweat, shit, tears, spit, piss, cum, blood. The amphitheatre was there to attract the people, which are the aristocracy. The whole complex and the community of the temple received state sponsorship and support during the theatre festivals. The amphitheatre was part of the temple and both were part of the state; mutually supporting each other through the ruling system known as democracy. The term 'catharsis', which is a theatre term, derives from the releasing of illness in the sanctuaries of Asclepius. But what kind of virus and sickness were the citizens releasing in the amphitheatre? They were abandoning their differences.

The acoustics of the amphitheatre are as imposing as the background music of a mall, making the audience feel equal among unequals and free among unfrees. The acoustics are engineered so the people can fully listen in perfect detail to the actors' actions, but they cannot themselves be heard. The actors' voices are of such clarity that it is very difficult for the spectators to deny their inclusion in the narrative of the play, because in real time they are part of the actors' voices as well, since every action that comes from the corresponding audience immediately sets the mood of the performance happening on stage. We need to understand that the stage of the amphitheatre is not only the circular focal point of the end of the seating area, but the entire structure and its surrounding acoustic effects. While the drama takes place, it includes everyone: spectators and actors create a total, accurate reality. This co-dependence between spectator and actor is the foundation of social divisions and the state. The amphitheatre is the state's propaganda to the voters, those who establish democracy, who are the aristocracy. It is the form of symbolic recognition and acceptance of the roles of those who give power, to be executed by those who represent them. Both sides agree to participate and submit to this form of recognition. The form of the amphitheatre purposely gives the sensation of a reciprocal inclusion, which is also the form of the state and its mechanisms of control. The genius of the acoustics of the amphitheatre is based on its design. Its shape allows for listening, but also allows the spectator to submit his presence within the construction of an illusion of belonging and security as part of a whole. At the same time, that spectator loses his voice and submits to the basis of democracy, which is representation, through releasing his own power to this whole, for a sense of belonging. This security is connected to the safety that both institutions of health and religion provided in the building complex at Epidaurus.

The performance in the amphitheatre is an extension of the state's performance. The state created the amphitheatre

within the institutions that supported it, that is, the belief system of the time, the religious and health institutions, which were also mutually supporting each other, given that ceremonies of healing were executed by the priests of the temple. Absent from all of this were the slaves and the women: they were not people. They were absent from the amphitheatre exactly as they were absent from the city and the *demos*. Without any presence, they had no identity, there was no context for them to have agency of their actions. They had no voice, no participation in public, so they didn't exist. They embodied negative dialectics, as they constantly provided surplus representation again and again through their exclusion, and also through their labour in the home and their labour on the land. On stage the female characters were played by men. The citizens were a group represented by the chorus, expressing the opinion of the democratic majority. They had one unified voice to speak with and one common movement. The slaves and the women didn't exist, they were not allowed to be on the street, to be seen, because they were the state's property. Their actions were given to them as re-enactments of their masters' actions. Their actions were provided to them as scores so they didn't ask for authorship and credibility for their work and words, because these were the executions and the property of their masters.

Epidaurus was a collection of institutions and technical networks in which living artefacts were produced, and were given political recognition within a predetermined cultural context. These disciplinary practices share similarities with what is now referred to as biopolitics, and what in the twenty-first century we tend to call pharmaco-military regimes. Certainly, as Paul B. Preciado writes, 'We have come face to face with a new understanding of space and the body, but also of the production of power and of the subject (both subjugation and subjectification)'. But we haven't arrived at any different understandings of freedom and the destruction of power as such.

stage of recovery 133

'I could stand in the middle of Fifth Avenue and shoot somebody and I wouldn't lose voters.' What does this statement mean? To kill a man on the street is murder, that's for sure, but to commit murder and still be a president means you are an oligarch, a tyrant, a dictator. During the revolutions of the past, artists, activists and political figures including presidents were murdered; now presidents threaten to murder the people they represent. To vote for a person who commits a crime is not just loyalty, it is silencing. This totality is in the lineage of the amphitheatre. Democracy was invented to silence some parts of society and bring some to power: now it seems that society is ready not only to accept this and act upon it, but to submit to it as an unavoidable evil. There is a need to recognise defeat in order to revolt. There is a need to recognise pain in order to ask for help. If we are endlessly pretending that everything is OK, that we are ready to find solutions, when we believe that we haven't made any mistakes personally and socially, there is no way to transform what is going on. Society mimics itself, re-presents and repeats itself, instead of letting us live. There is so much pain, so much humiliation, so much extraction, and we are still waiting for the warmth of this wholeness of the theatre and representative politics to provide us safety and a voice for which we are not responsible. It is not through making demands or asking for someone to resign that the ontological blockage of giving up the political responsibility of our actions will be solved. The blockage is the way we were taught, willingly or with violence, what freedom is. To paraphrase Beauvoir: 'If every man is free, he cannot will himself free. Likewise the objection will be raised that he can will nothing for another since he is free in all circumstances, men are always disclosing being, something is always happening in the world, and in the movement of keeping distance, can one not consider the different transformations with detached joy, or find reasons for acting. No solution is worse than any other.' Let's call this contemporary attitude 'aesthetic', because the one who adopts it claims to have no

other relation with the world than that of detached contemplation. Despair, fear and anxiety are noticeable historically when there is confusion, crisis, political discouragement and ethical withdrawal. In extreme totalitarian paradigms like those we live in today, the noise of the action, the world, is gone, the interior of the body is coded, speculative, scientifically categorised and named. The body becomes more sci-fi than the unknown depths of the ocean. The natural resources of the south of the planet provide the luxuries and the power of the north. South and north exist everywhere, in our relationships and in our interactions. The fragmentation of the Earth through the trafficking of resources, bodies, organs and people in the name of economic and political tyranny has transformed our way of understanding power. There is only dichotomy. Man is not only creating the world, he also creates his existence as such in the name of a power of representation.

Each one of our revolts, needs, hopes, rejections and desires are active processes of freedom, and they cannot be achieved if we believe that we are already free. I am not free: performance is an anti-disciplined medium of empowerment. I jump in the wound, learn from pain, find my way to language, assemble, gather together, speak, unlearn and listen. Organise life with others. Hear my insides, they scream, sense the world, be more sensitive. And I won't always try to understand, I will be part of the world. Anarchy – *an-arche* – means 'without beginning', 'without origin', it is an unbound ontology of time. I will practise that – be aware of it – there is no beginning so there is also no end – there is no project – there is an endless appreciation of what is around. To be hyper means to play with the unity of the aesthetic object – my own limitations and distances – so I am able to feel and think and come closer to another. I will go beyond the double. Act upon the breaking of its dichotomy with uncertainty, curiosity, and be adventurous. The one will DOUBLE, the two doubles, triples and multiplies, reflects like a crystal. This is me, and this is what I do, and what I want is to continue practising.

Some notes for the General Assembly

This past week's Occupy Wall Street has witnessed rapid bureaucratisation and centralisation of the General Assembly. Specific working groups, most dramatically in the context of the operations spokescouncil, have authorised themselves as the ritual keepers (via dogmatic facilitation/process/structural rules) of the movement. This has created confusion and ambiguity in the public discourse. It has prevented each individual from empowering themselves to create or act in the GA without being identified as a professional participant. We have seen (the prioritisation of) money issues and organisational questions ruling most of the assemblies, while putting aside the reasons and frustrations that led to the occupation movement. This, inevitably, means a schism between the ones who authorise and the ones who are here to participate.

We call for an open General Assembly for all.

We don't ask permission from anyone to be imbued with that authority. We continue to learn the possibilities of direct democracy from each other.

The General Assembly comes as a necessary, imperative act that makes urgent a radical overthrow of the system of political representation, the state, and the commercialisation of everything. This social organisation does not leave space for any hierarchies, leaders, governors or political parties.

It gives space for every individual to experience and practise politics, and at the same time to be transformed within it. It is for all people to experience the joy of personal initiative, of collective effort, of solidarity, of love. All resources of our common life and the means to satisfy our common needs, cannot but be common in the hands of society itself. Which, with no mediation, decides an equal distribution of these faculties for all.

1. All space is open for everyone's participation, and belongs to everyone.
2. The equal participation of everyone shapes the making of decisions, as well as the control of their application, both in the political and economic fields.

3. All necessary delegations have a strictly coordinating or executive nature, and not a mediating, representative or decision-making character.
4. The existence of many local assemblies (in neighbour-hoods, municipalities, workplaces, schools, etc.) is the cornerstone of direct democracy. Participation in these assemblies is not occasional; rather it is as responsible and regular as possible.
5. Communication between local assemblies creates a horizontal (non-hierarchical) network, which serves to coordinate the required theses and acts.

We want everything for everyone. We are history in motion. Now is the time to overthrow all forms of authority.

General strike

It is not a matter of whether all of those involved in the general strike can or even should come together under some ephemeral political umbrella to plot a shared course with clear, concise goals and agreed-upon demands. The truth of the matter is that the general strike needs no demands. In fact, ideally it would abhor such a configuration, insofar as those of us striking know full well that our own angers and desires far exceed any demands, or set of demands, that might be made. No laundry list of fucked-up conditions, or of alternatives or solutions (which always precede, assume, and ultimately fail to attack the injustices they seek to address) can even begin to exhaust the range and scope of our rage. Likewise, the Occupy movement more and more openly transforms the tiring effects of excessively passive petition drives, letter-writing campaigns, and permitted marches and rallies where professional activists are both literally and figuratively penned in, separated not only from their ostensible targets, but from one another as well.

We are the 99%, therefore we need to creatively rethink what a general strike might mean for us in 2012.

- We act collectively to establish new and inspiring forms of mutual aid and solidarity.
- We imagine how we effectively go against the systems of racial, ethnic, gender, sexual, economic, political and police oppression.
- We realise we live in a 'stop-and-search' world within which everyone is illegal and this illegality is apportioned according to predetermined privileges. Police brutality and its naming are increasingly normalised. The term 'police brutality' normalises the multiplicity of capitalist and state violence.
- We govern ourselves, meaning we act upon social problems by our presence, commitment to and sharing of the commons. We are open and public, and we are not afraid to speak and act.

- We create new ways of being and living together, outside of wage and property relations. This especially means that we are thinking of ways to support those we work with, rather than those we work for or earn from.
- We start learning how to develop the strength and courage to view and treat our lives as they truly are: NOT NEGOTIABLE!
- Most importantly, general strike calls for infinite strike and not just for a day of action, because it calls for social change. It calls for transformation. It is for each one of us to make that transformation possible on the streets, we make the city our playground and we abandon the places that oppress us. We stick with each other and we do not make metaphorical gestures but actual actions that promote our efforts. We enjoy, we share, we change ourselves and others, we move forward. This general strike then is life, and only by envisioning how our lives should be can we build this global general strike. From the May Day struggle that brought the eight-hour working day, to the people who want it all for all: EVERYTHING FOR EVERYONE! GENERAL STRIKE! NO WORK! NO SCHOOL! NO SHOPPING! NO BORDERS! TAKE THE STREETS!

30.04.2012

Hunger strike

Today, 10 March 2021, I have completed ten days of hunger strike in solidarity with the prisoner and hunger-striker Dimitris Koufontinas. I, alongside thousands of people, continue to defend his lawful request to be returned to Korydallos prison, as has been confirmed by associations of lawyers, academics and artists. An intervention made by the Lawyers' Association requests the Greek government to reconsider its position on the prisoner.

What is it that makes us demand our rights? If good is not demanded it cannot be applied. For something to be applied it has to be a routine, a habit, a way of life. Who are the ones to verify what is good and what is wrong, what is logical and what is unorthodox? Those who are subordinate can rarely impose their position, and unfortunately sometimes it happens only at the expense of those who are in an even worse position than the subordinate. It is certain that good will never be demanded by those who are expecting invitations from those in power, waiting to be validated by those who own everyone's surplus. The majority is fighting each other over the bits and pieces of their own surplus.

No one is left out from the absurdity of the struggle to survive. To get the 'bread' a person can turn from victim to perpetrator in an instant, sacrificing many of their freedoms. We are surrounded by thousands of victims, who are judged as perpetrators by opinions such as 'they had it coming', 'they should get a job'. The word 'bread' declares the right for each and every person to a dignified life, lived in conditions that feel useful to themselves and to others. The requirement for independence and free choice has gradually, during the economic crisis of the past decade, become more like a utopian demand that can only exist once we have eradicated our beliefs and personalities.

'Bread' implies housing and shelter. The place where a person can protect their necessities, it is the fundamental element of personal care and protection, through which collective need can emerge. The government and its delegated

officials – whom we trust to represent us – have the primary obligation of creating the principles for social wellbeing, not investment growth. The government cannot expect us to be mere consumers and spectators. The operative obligation of the government should create the conditions for balancing social polarisations. This can be achieved through job creation and wage stabilisation, instead of an increase in taxation and the price of essential commodities; and by applying the law equally to all persons: to those who have a passport and to those who do not, to those who are imprisoned and to those who are not – to everyone. Then we could live on equal terms with fair laws of protection, care and not subordination, violence and misery. Therefore, the government should first and foremost protect 'freedom', an essential element of justice and democracy. Otherwise what is the reason for the state's existence?

It is inconceivable that for many years now, globally, under the pressure of capitalism, which has transformed into a financial-economic dogma, different states rapidly sell out public and natural wealth. States whine about the extreme povertisation of entire continents and disregard the humane in political and economic coordination. Their gazes are withdrawn from the bodies which are violated and harmed, the bodies in the concentration camps, the bodies of the workers and of the prisoners. Instead they search for investment solutions in order to adapt a form of numerical management.

We are placed in the roles of passive receivers, spectators, numb to and compliant with the struggle for survival. With police violence, the approval of laws against the freedom of political expression and the right to assemble in public, and the dissolution of basic human rights, we have lost every bit of drive to propose and to name a new horizon for life, because we have lost the motive to pay attention, to empathise, to sense. While refugees and the homeless are left to the mercy of political and financial speculators, the abolition of university asylum, which prevented state influence

on campus, along with the bill on policing universities is considered progressive, leaving thousands of students, as well as their professors, vulnerable to arbitrary police violence. The pandemic operates as an excuse to classify and normalise existence as sick, incapable and illegal. The general transformation of the welfare state into a surveillance state, a state of financially dictated execution is certain. The government is spending public funds on the transformation of public spaces into battlefields.

The state is attempting, in every possible way, to poison the motive to live by disregarding any self-determined action and pushing thousands to diminish their skills to mere services and part-time jobs. The government attempts to control life to secure the state's position as a customer at the European Central Bank.

The phrase 'freedom and bread' derives from the French Revolution and has been used ever since whenever the people's rights are threatened along with democracy. The word 'education' was added to this phrase and used as the motto of the revolutionary movement against the fascist dictatorship in Greece. This spontaneous movement was born of the youth. These three words put together, 'bread–education–freedom', remind us of the power of education and art to cultivate the basic values of society: to claim life, empowerment, expression and to realise ideals that do not revolve around money.

Any act of self-organisation appears to be a dream or pure luck these days. We artists, who have had no guarantees of becoming artists, and at the same time have no guarantees of our future as artists, find ourselves still acting with our own initiative, aware that this strength and possibility lies beyond goodwill, as such acts cannot be categorised as labour. The violence that is currently exercised is upon bodies that wish to exist beyond merely carrying out orders for survival. Bodies, in the simple, sincere and genuine nature of their practice, are inherently present in the meaning of self-governance and

self-determination. They are the crucial elements of artistic practice as well as of the political act. Our continued claim on this aspect of our existence appears to be inconceivable to global hegemonic capital.

Showing solidarity to the prisoner Dimitris Koufontinas' just request does not require identification with his ideas or his actions, which have been judged at his trial. Instead it educates us in a position of humanity and justice, in a shifted position of defending life. It places us in a position of securing self-governance for everyone, of protecting freedom, and of creating supportive systems for all beings who are currently harmed on earth. My decision to hunger-strike and to place my body among all the other bodies that fight for what is just and good is a dignified decision, a decision to defend the free and self-governing body. My own participation in this struggle aims to put my body next to a human who turns his body into the ultimate weapon against authoritarianism and inhumane state violence. As Dimitris Koufontinas is between life and death I choose to end my hunger strike so that I can now meet with everyone else still fighting in the streets against this government's arbitrariness.

Truth and love is one in action. Body as weapon.

ART STRIKE

ART STRIKE is constituted by:

1. *The design of a website for the purpose of supporting artists, curators and anyone working in the field of the arts in a potential strike.* The site will provide an account similar to other solidarity funds. This is in order to address the issue of the everyday expenses incurred if an art worker decides to call a strike. In the case of the arts, strike has a minor but very particular difference from other working fields. The individuals working in the art world are isolated from each other and they cannot call a mass strike; through the site however they can individually create a mass strike. The site will provide information on the number of strikes and their participants, when they occur. Even if this takes place in an individual manner, in various places in the world, the site will give an image of the collective effort by providing a page where all the strikers may write to each other and share experiences and skills. The site will not only give financial support, but will also be a place of connection. Exactly because there cannot be a defined place or practice to manifest the strike in the art field, the site could fill this symbolic gap. One could say that the site is the strike insofar as the participating individuals use it as a place to talk, exchange ideas and communicate on the unique condition of striking. The site is a strike insofar as it is used for the cultivation of dialogues on the issues of how work is valued, on what material and intellectual production is, on what their effects are on people involved in the arts, and in relation to the rest of the world.

2. *The physical manifestations of the strike.* In the case of the art strike these manifestations could take various forms: throwing flyers from a balcony, not replying to emails or picking up the phone for a day, organising a public collective action, rioting, creating public discussions. Because the site will connect people, it could also be a

place to promote and post mock-ups of flyers, posters and videos that call for actions in physical space.

ART STRIKE can be a paradigm of organising for other working fields with the same characteristics as those found in the art world: precarity, antagonism, egoism, isolation, discrimination and disconnection.

18.06.2013

Feminism

Everything is exhausted. These girls from this squat, how do they feel? I don't know how to approach the situation with them. Honestly. Because where are they now, after what happened? They wanted to throw me out of the discussion, and I talked about how I think all of it is a fabrication, and I left on my own. They were fully implicated in all of this. I don't know who they are. I couldn't catch their names. If I saw them I'd recognise them. Does this make sense?

For the first time I see a link between what happened in the 1970s and now. How women's consciousness-raising groups used the fiction of original identity, and the narrowing effect of this on the feminist movement. Where struggle turns into exclusion. I have never experienced a madness like that. I haven't seen little cops in a feminist gathering until now. Never seen zombies like that, bio-cops like that, so interested in our sexuality. There is no allowance for conflict. The bio-cop doesn't allow conflict. Once you disagree, there is no possible way for anything to happen. It feels so insane to me that I cannot disagree. Why not? At the same time there is exclusion through politeness. What is this? Fear? What are these people? How were these people educated? In the army?

I don't understand why I was invited.

We met and you told me that I would want to know about this squat.

I arrived at the gathering and my gay friend was there, he is very much involved in gay rights. He told me he decided to be at the gathering because he wanted to be with me. Likewise. I wanted to meet with him so much after many years of not communicating.

I am there and I don't yet know who has invited me. He knew about it the same way I knew about it. He received the same email about a feminist gathering, which promoted secrecy for the gathering. To protect the participants. I thought: most of the time when meetings promote secrecy it is because there is an urgency, which is the reason for the secrecy. Secrecy is interesting if there is a unique urgency of

an action of planning. What happened there registered some very important things for me, in that I was in such an uncomfortable position and there was information that I didn't know how to address. The way the gathering was organised showed what was coming.

My friend and I had a discussion about the construction of subjectivity. How the post-Soviet era is informed by the rapid shift from the supposed communist subject to the supposed consumerist subject. He was trying to explain to me that it is so difficult for post-Soviet, newly independent countries to get rid of their dependency on Russia and also register their individuality for the capitalist agenda. The post-Soviet countries know that they have to submit to Europe as a construction of belonging. So everything goes through a pre-packaged process to create a consumerist subjectivity submitted to a system of total control. He said it is something that is coming to southern Europe, where there are other memories, histories, struggles, experiences of resistance still to be erased by the European project. I had this impression in China, that this happens in submission to the neoliberal-nationalist Communist Party. The art scene there needs capitalism to be taken for granted, it is advanced capitalism. What the Party advocates for is another type of colonialism, internal colonialism, coming from this perception of being part of something which is not even communism but neoliberal capitalism. In a way Europe becomes an ideology which is against any critique of ideologies, this creates what a European is. What you see is that Europe is used as an ideological product to destroy any kind of ideology, such as communism.

In the classic period of capitalism, not the post-industrial period but after the second world war, there was no need for production, capital was made through destruction. During this period, the only production was through war. In five years the Middle East will be destroyed, out of this destruction more money will be generated to rebuild it. How

do I make money without production? I extract, I destroy. I destroy and I make money. General capital doubles because of the destruction. The people won't exhaust themselves because they will always find a way to consume. If we have constructed ourselves to consume what else can we do other than consume? What else can happen? This is life. Consuming is life. Institutions are products of this life, they support, participate in and sustain it. Destruction and its corresponding mentality is distributed in all corners of society, in culture, education, everywhere. Everything supports this way of understanding life. Life as a given, as a construction, as a support for humans to exist and to continue to consume. Infantilisation has been produced.

The construction of subjectivity is the epitome of not admitting that subjectivity is social. It is the illusion of belonging, it is the destruction of anything that could be social and public. The destruction of the critique of already existing institutions.

My friend mentioned that the gathering had been organised by an NGO, as are many things that have an activist character and intention. We ended up deciding that we need to discuss this at the gathering. Because this is the problem. You might have people who want to organise, but the format is already so particular that nothing else can happen. When you go to a feminist gathering that is anti-military it would be good to discuss NGOs.

We decided that it would be good to initiate a discussion about the idea of the commons and the idea of subjectivity and how to get out of the construction of the self, perhaps through the creation of the commons.

The next day we meet to take the bus and while waiting I meet this really nice girl, who is very happy and wants to be part of the gathering. We are having a coffee and then two queer punks approach the table, both from Germany. A couple that run a space and both identify as she. It is a nice atmosphere. We are on the bus. My friend's brother is

there too. We are going to an area which is close to a heavily militarised zone. Most of us don't know where the location of the gathering is, somewhere in the countryside, close to this zone. I also meet one of the organisers, the one who invited me to the gathering, who is a good friend of my gay friend. I ask her if the girls from the squat would be at the gathering. And she points out that they are on the same bus as me. I approach them and try to be friendly. They don't say anything to me. I think: another couple. A lesbian couple. So, already we have two couples. A non-binary couple, and a lesbian couple who say that they come from Athens but obviously come from somewhere else. And then on the first day during orientation another couple appears, who say they come from Palestine. Three couples. At this point I didn't know where all these people are coming from. We are still going to a feminist anti-military gathering. And there are people who are expecting us.

I feel that this is a trap.

In the beginning they describe how the space is organised, that there are four floors, that the second and third floor are for sleeping and the fourth floor is the kitchen, where the larger meeting will take place. And they tell us that we will have an introductory discussion in the afternoon and that the food is already made. So it is clear when I approach the kitchen and the people in the kitchen, whose names I never learn, I am treated as a customer. Or that they take their work very seriously. Also, the food is vegan only. There is no alcohol. I want to say that this kitchen issue makes me feel that the organisation has already appointed people to certain responsibilities. So it is really the other way around from the form of the email, which looked like an open call for self-organising. The NGO organisers didn't make a clear claim that there is no responsibility required from us, but the responsibilities have already been assigned by them.

The kitchen is treated as a restaurant by the organisers. If this was a conference, we would go to the restaurant when we

needed and it would be open. Then it would all make sense. Instead, we have the privilege to eat and give presentations about topics, which de facto expresses our gratitude to the NGO. This is the NGO format: the call to self-organise never takes place.

Urgency brings self-organisation. In the urgency of a situation, nutrition is us being together. Two days ago, when we discussed subjectivity in the evening, I didn't go to the toilet for six or seven hours. I realise that the body is the agent of urgency. There are practical issues, for example, that the place is far from access to food, and these things need to be taken care of. The point is that we could take care of them together. Then we would not need an agenda. We are between two villages and could create relationships with the people living nearby, understand how women are treated there, how we can connect with them. What we make are not places of exile. We don't have anything and we don't want anything in order to be. To give what we don't have. At the same time we need to expose this condition of passivity, this 'this is how things are', and the mode of business-as-usual.

I don't know how to stop this manipulation. The radical scene is turning words of empowerment into authority.

Staged
Sunday News
You will call to order me
Feelings
Regret over lying is not a simple act of accounting
Self-awareness is a sign of lack
There is no truth
When you are either for or against
Lies for a life, for a face, for the tone of your voice
Lonely as you are
Strange as you are
This is how it is
Sunday again and it seems that we are back to '69
Or the Middle Ages when the terror was god and
The gods were killed on purpose
For the clarity of profit, no one remembers details
No one tells us how everything started
How did it happen
I fantasise about being someone else
How it could be to be a man and then how it could be to be
 a bird
A tree
Body made out of soil manipulated into narratives of progress,
 effect, emotions that can barely touch the earth
Constant ordering
What did I learn
I crash to anger
I am terrible in analysis, I beg you to hold me and invent
 with me

She is breaking the door. She is not talking about it.

I think there is no trouble to the norm. Just tiny explosions. I am going from the Brooklyn General Assembly to the Bed-Stuy GA, and talking with a friend from the Bronx I met three days ago who is angry about the GA model. I am trying to find a way to be at as many places as possible. There are some disgusting power dynamics with the Occupy Wall Street facilitation working group. Process has so rapidly become a protocol for any GA that takes place in the whole country. Too much professional activism I guess, and too much commitment to the 'cause'. Sounds like the struggle within the struggle. Professional activists are always the first to put on the brakes. Is it possible to push action that does not come out of ideology, radical symmetry and liberal monotone language? Is it possible for anyone to do more than just meetings, and to go out on the streets in their own way? The community as a notion is used to barricade and prevent the threat to authority. I am tired of empty critique, elitism, paranoia, fear, and all of those political experts who are certain that they know more, and better, than anyone else. These are our limitations and friendship is rare. It was too naïve of me to think that friendship is de facto, and a stronger force than anything else.

Yours, G

She is breaking the door. She is not talking about it.

I refuse to support this pretentious parade of constant nego-
tiations. The art scene, the activist scene, the academic scene,
the radical scene, etc., each one of them, they are *classes*
functioning only for their own sake. We are all rotting inside
our perfectly determined cells. Difference is not allowed,
everything must be the same for the capitalists' totality. We
understand each other perfectly and we politely pretend that
everything is rolling on OK. During our desperate actions, the
academic watches from a distance. He parasitically appears at
our gatherings, to give us back the story we have already cre-
ated, to feed information back to spectators, who post com-
ments from their sofas in an endless navigation of the web's
informational circuit. Science and capitalism impose fabri-
cated realities supported by governments that are run by cor-
porations. I've been living in the US for six years with a visa
that expires in a few days. I am dry of cash and I don't depend
on credit. Seems then that I am already out of this country.
If you want, please let my so-called friends know that I de-
cline to see them. I have no interest in presenting myself
at any of their spectacular events, their protests of amazing
significance and their groundbreaking discussions that shut
down argument, and put pleasure and passion in the freezer.
Having experiencing personal attacks for almost a year, I am
emptied of energy to walk their streets, and to be curious as
to what they are up to. On 17 September a famous anthropol-
ogist posted my name on Twitter claiming I was one of the
people behind the creation of the General Assembly and the
Occupy Wall Street movement. In October 2011 the executive
director of Artists Space gave my name to the press and, by
extension, without a second thought, to the police, accusing
me of leading an occupation. A few days ago, I accepted an
invitation from Artists Space for only one reason: to express
again my 'No's in public. This responsibility is very clear in all
of my actions and words. I am a political being and I am an
artist. I will not let anyone limit the seriousness of the current

global struggles and repress my decisions by creating media humiliation and undermining the value of political expression. The US, let's not forget, is the centre of the global totalitarian economic and political system, and the subjects who run this machine know very well how to paralyse public anger. I am personally tired of being singled out and violated every time I speak my opinion, and of having someone appear attempting to silence me each time I articulate tactical concerns. Either you like it or you don't, I am here to remind you of our freedom to live, act and speak our thoughts, and when I am under pressure, I will fight more strongly. I am not afraid, and I will not ask for permission to enact rights that people before me gained for me. Although it seems that there isn't much urgency for a strong social uprising and mass opposition in this country, we should not ignore the issue's complexity, that it is to do with the cultural and political powers that heavily support the hypnosis of this society. I am not going to continue to eat the capitalist's paradigm that *through survival I will be able to live at some point.* When I hand these words to you it is even clearer to me the need for the continuous fight for global freedom and equality. I will not tolerate oppression, discrimination and violence to any being: human, animal or natural organism. I will continue to act and vocalise in order to empower myself and everyone around me. This revolution has just begun.

If you don't see me on the street you won't see me at all.

Yours, G

Acknowledgements

I want acknowledgements to speak out without conclusions. For this reason, I try not to use quotes like credentials, like we often do to respectfully represent knowledge and to make sure we show our own powerlessness through seeking power. I will insist on vulnerability now. I will have conviction that those who formed me reveal themselves in my words. Anyway, my speech is not a final statement, nor a mode of transmitting conclusions. It is a process of plugged-in thinking, an understanding that seeks to encourage myself and others. This voice acknowledges the scarcity of experience. Suffering cannot be described in words, it vibrates, pours out texturally, and seeks attention. Pain must be acknowledged to be followed: not as a neglected code, that for centuries has been demonised, but as a bell and a compass of the unique conditions of our actual, internal states, behaviours and affairs. When we listen through pain, there is the promise of change.

We ask for help when we are in despair, but what if the motivation towards the promise of help was shifted into a continuous practice of our conditions, an emotional practice that brings out what is hidden deep within. How can I say what needs to be said with unapologetic sentiment? What is my motivation? Faith? Sense of responsibility? Justice? Rage? When it starts, it begins, with a motif that sets you in motion, giving you motivation to wake up in the morning. Although it falls in the realm of sensation, although it begs for another term, you don't know how to name it.

In Greek, what we now call the atmosphere was the Ocean. In the description of how the world was made we find the need to know how everything began, sometimes described as the split that happened between Ocean and Night. The Ocean is the surrounding water that holds everything together and the Night is everything that is beyond. In these descriptions, life is the Ocean and the Night is death. Ocean is the body as we experience it, endless, deep, vague and unknown. If we are the Ocean, what is surrounding us is Night, an unknown,

fog-ridden environment, but death is not out there because we carry death within us.

Ability refers to one dominating model of how a body should be, suffering to try to find a beginning point, a frame to settle in and then be. We suffocate to demand categories in order to go about the right to exist, instead of caring to cultivate a non-beginning axiomatic approach to life. Spirit is in all humans and nonhumans, in every entity love takes shape, and we waste energy in violence, extraction and domination. Our passion is to fix things instead of letting them be.

Do you need to know who you are in order to take care of yourself? How can you know yourself when you learn that knowing is in itself power? To love and care for another, even if this care is for a stranger, someone who you might think you know, or God, spirit, entity, that is beyond comprehension, that feeling of care for another, here will not be named Ocean but horizon. Here, we will acknowledge the interior muscle, the diaphragm, always in correspondence with the gravity of the earth. If the spine creates the collective, we want to create the personal horizon through the unique interior muscle. The diaphragm is a metaphor, an idea, a term but also an actual organ that is situated between what we can call the upper and lower parts of the body. The upper part receives, and the lower part releases. The diaphragm is needed to create a sense of limit, a way to realise an interior reference that balances those two states of receiving and giving, inhaling and exhaling, because this horizon is our interior gravitas.

The voice follows the breath and to want to breathe is to have the drive to bring the tune of the voice back through the deep thickness of the darkness of the world in the unknown of your insides, out into the world and back to the roots of the earth.

In attention and observation, we will notice that in every bit of the world there is also the desperate need to be, and for something to be it needs another to recognise it as it is. If

I am on my own without another, how will I know that I am the one for the other? Every being is because there is another to recognise this being. To be a stranger to yourself is to be a stranger to the world.

The world of spirit confronts the struggle for power: this vicious circle that we have programmed ourselves with in definite conditions and definitions. The struggle for power, in any form, cannot be disregarded. If power becomes our law and order, the ones who suffer, the ones who are in pain, will seek help from those who seem in power or will seek truth by powerful means. We need to insist on a spirituality that breaks this curse by putting ourselves into the condition of the minor, the one who suffers to seek the truth. We need to make our suffering and pain our information and to come closer to others during this shift. To insist on paying attention to the particular, not as a category but as significant, unique and sole. With those terms political organisation becomes an address to all who have no face, no obligation to affirm themselves through category but through presence. The assembly becomes a cure, an imprint and an operation of belonging and communion. This practice of self-awareness through public awareness is a possibility that is actualised consistently and in daily practice. This practice does not seek to create a closed category but appreciates and respects the formation of change as is. This I call spiritual anarchism.

Acknowledgement is to remember friends in New York and the organisers during the Occupy movement: Harout, Matt, Matt, Norhan, Clark, Cosmo, David, John, Stephanie, Nicole, John-David, Alaine, Natasha, Rob, Jeffrey, Silvia, Rene, Ayreen. Acknowledgements go to those who co-organised the Artists Space occupation. Thank you Fia, Karin, Sabu and Diego for your friendship and for your help in returning to New York after my passport was held by the US Embassy in Greece.

It is not certain that we are moving up and down, in and out, left and right, there are movements that come at

strange angles, movements that take longer than we have the tools and perceptions to track. Also there is the change of an object's motion according to the observer. If we don't know who we are, what makes us be? How certain is it that we are here if the only things that prove it are the systems that fail us? Institutions are us, but who are we to know what institutions we need, or don't need? Are our societies on autopilot?

Saliva sleeps behind the tongue while the beat surrenders in the heart while the blood listens and they finally stop competing. Paint settles, material unrealised, as it is, you don't have to soothe its substance. The paint: ground and water, spit, urine, blood, tears, sweat and plant, leaf, feather, colour comes from the mixing of pigments, things. When you apply it, you adapt it into form, that's how neurons adapt their light into perception, and try to speak it, to express it, even before you have anything really to say.

Versions of the sound of your voice have appeared as attempts, in a variety of correspondences: tuned with the desperate need to sound like yourself, but in the end what it sounds like is pain, fear, shaking from the veins of the stomach. The edges of your fingers weaken, your voice is somewhere far away, you speak but you end up a hunter of your own voice. There is no way to catch your voice if you expect you have to understand your body, and then for the voice to follow.

Your mind has been separated from your body like two splits of the same material in different weather conditions. In your mind is a storm, and in your body is a desert. Can exterior sensations shift this, when every sensation is demonised? Perhaps, but there will always be an internal police to maintain the split. The need just to be will be connotated as violent change, and will immediately trigger only an extreme recuperation, defending the split. The heat of the desert will become ruthless and burn everything inside and the stormy mind will flood with thoughts, memories and signals mixed together all at once, like an electric shock.

Acknowledgements go to the performers who participated in the artwork 'Dynamis'. Acknowledgements go to the thirty participants who trusted me during times of confinement to conduct the one-to-one 'IASI' sessions, and to those working with me to make that possible: Maria-Thalia, Olga, Daria, Divya, Monika, Ariadne, Lucie, Chala, David, Lu, Hannah, Bardhi and Charlie. Acknowledgements go to dear friend Allison, who introduced me to Divided Publishing. Acknowledgements go to dear friends Monika, Sotirios, Dionisis, Alexios, Emanuel, Fabrice, Daniel, Ludovica, Oscar, Oliver, Igor, Chus, Roger, Sofia, Jennifer, Leigh, David, Katja, Alegia, Korina, Agape, Maya, Natasha, Sarah, Yve, Calamity, Paul, Mayra, Jim, Antonis, Sofia, Nora, Manos, Eva, Domenick, Blake, Eva, Irene, Panos, Yiorgos and my two brothers Tasos and Vagelis. To all the allies, comrades and all the friends of friends. May we all meet. And acknowledgments go to my grandmother Sofia and mother Maria who taught me the Greek, pagan-orthodox traditions, showing me the importance of love, sharing and connecting to God, saints, angels, spirits and ancestors in day-to-day life.

It is uncertain who you are, where you are located, and the cosmos is the breath.

Some of the texts in this book were written during a communal organising effort and their authorship is not exclusive. Parts of 'This summer had too many eclipses' were delivered as a lecture at Hochschule für Bildende Künste–Städelschule, Frankfurt am Main, on 29 May 2018, and at the conference 'Hiving: Living Forms, Forms of Living' at the NYU Tisch School of the Arts, New York, on 5 April 2019. In this text, 'Zak' refers to Zackie Oh, Zak Kostopoulos, an activist for the rights of LGBTI people and HIV-positive people. On Friday 21 September 2018 they were brutally murdered on a busy pedestrian street near Omonoia Square in central Athens. This death has yet to be brought to justice. 'Hi D' is a selection from email correspondence with anthropologist David Graeber. Parts of 'Performance study group in Zurich' were delivered at the Zürcher Hochschule der Künste, Zurich, in spring 2018. 'Conflict' is an excerpt from 'Party for your right to fight: An interview with Georgia Sagri by Gareth James', originally published in *Texte zur Kunste*, issue 87: 'Streit/ Conflict', September 2012. The care reports of '"IASI"' are from the one-to-one sessions that formed the exhibition 'Georgia Sagri: IASI, Stage of Recovery' which spanned January 2020 to January 2021, and was hosted at and supported by three institutions brought into alliance through Sagri's research: de Appel, Amsterdam, Mimosa House, London and Tavros, Athens. 'Amphitheatre' is a lecture delivered at Hunter College, City University of New York on 9 October 2019. 'Hunger strike' is a translated version of a press release sent to Greek media on 10 March 2021.

Georgia Sagri (born Athens, 1979) lives and works in Athens and New York. Her practice is influenced by her ongoing engagement in political movements and struggles on issues of autonomy, empowerment and self-organisation. From 1997 to 2001 she was a member of Void Network, a cultural, political and philosophical collective operating in Athens. In 2011 she was one of the main organisers of the Occupy Wall Street movement in New York. Since 2013 she has been a member of the assembly of the Embros Theatre Occupation, and in 2014 she initiated Ύλη[matter]HYLE, a semi-public cultural space in the heart of Athens. She is professor of performance at the Athens School of Fine Arts.

Photo: Ioanna Chatziandreou